NEW DESIGN
PARIS

GLOUCESTER MASSACHUSETTS

series editor: **Edward M. Gomez**
associate editor: **Patricia Strathern**

ROCKPORT PUBLISHERS

NEW DESIGN
PARIS
THE EDGE OF GRAPHIC DESIGN

First published in the United
States of America by:
Rockport Publishers, Inc.
33 Commercial Street
Gloucester, Massachusetts 01930-5089
Telephone: (978) 282-9590
Facsimile: (978) 283-2742

Distributed to the book trade
and art trade in the United States by:
North Light Books, an imprint of
F & W Publications
1507 Dana Avenue
Cincinnati, Ohio 45207
Telephone: (800) 289-0963

Other Distribution by:
Rockport Publishers, Inc.
Gloucester, Massachusetts 01930-5089

ISBN 1-56496-560-0
10 9 8 7 6 5 4 3 2 1

Printed in China

Designer: Stoltze Design
Cover Image: Photodisc

Acknowledgments

I am deeply grateful to my Paris-based associate editor and collaborator, Patricia Strathern, a veteran photo editor in Europe whose firsthand knowledge of the creative scene, and whose diligent, insightful background research, have vitally enriched and helped shape the contents of this book.

I also thank my literary agent, Lew Grimes, for his energy and vision, and, at Rockport Publishers, editors Alexandra Bahl and Shawna Mullen, and art director Lynne Havighurst, for their keen attention and important contributions to the assembling of this volume and the development of the entire *New Design* series.

For providing helpful research information, our thanks also go to the French Cultural Services office in New York; the editors of *Étapes Graphiques,* France's leading graphic-design magazine; Christophe Girard, secretary general of Yves Saint Laurent; and Claire Senard and the staff of Time-Life International, S.A., in Paris.

Most of all, on behalf of everyone involved in the production of *New Design: Paris,* I thank the many cooperative, thoughtful, and enthusiastic graphic designers who have kindly shared their work and their ideas with us, and who have allowed us to reproduce them in these pages.

—Edward M. Gomez

CONTENTS

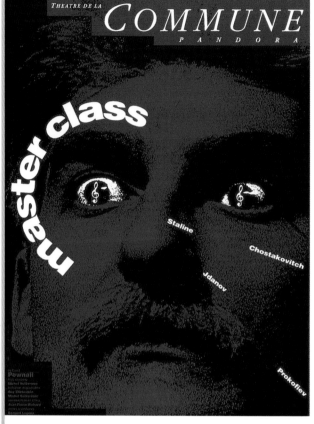

Paris boasts an unrivaled, centuries-old reputation as a center of the fine and the decorative arts; of music, dance, and theater; of architecture and urbanism; and, of course, of fashion, whose experiments, whims, and dictates have helped shape international notions of taste and style for generations. The political, economic, cultural, and intellectual capital of one of Europe's—and the world's—most centralized countries, Paris also has played a long role as a highly influential laboratory for developments in the graphic arts and in graphic design. These creative fields are inextricably linked to the publishing and mass-media industries, and to the education sector, whose leading institutions are concentrated there.

Perhaps nowhere more clearly than in Paris, in particular, and in France, in general, where modernism's colliding march of evolving art and design styles charged through so many studios, galleries, and salons so memorably, is the link between graphic design and so-called fine art so notable. It is to be found in the advertising posters that appear in every town and city for everything from clothes and dairy products to film festivals and social services. Sometimes it shows up as a stylistic flourish in a poster whose look may be more ambiguously abstract than one might expect, by comparison, of an American-conceived ad. Sometimes it can be detected in what French designers themselves say about how they approach their work.

After all, it is in Paris that the pioneering early modernist, the painter and printmaker Henri de Toulouse-Lautrec, produced his now-classic posters for dance halls, concerts, and other nighttime diversions at the end of the nineteenth century. Today, Toulouse-Lautrec's colorful broadsheets are studied and collected as prized exemplars of a seamless union of fine-art beauty and advertising-design innovation. In their fusion of elegance and functionality lie the seeds of France's long, rich tradition of the *affiche culturelle*—literally, the "cultural poster"—announcing such events as concerts, plays, dance performances, or exhibitions. Many of the Paris-based designers featured in this volume have created impressive works of this kind. Some are recognized contemporary masters of the form who exhibit their posters regularly in national and international shows devoted to this genre.

Malte Martin, for example, who established his first studio in Paris in 1988 after a stint working with the renowned Grapus group, often uses photographic images in his theater posters. "On this photographic base, I've intervened like a plastician," he has explained with precision. "I've sought to introduce fragments of light, color, matter, and ambiance that are those of the [theatrical] *mise en scène.*"

Michel Bouvet, whose poster-making techniques include everything from ransom-note-evoking collage to seemingly quick, brushy, whimsical drawing, has given considerable

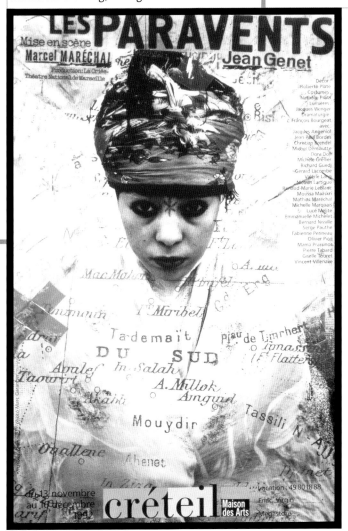

Poster for the play The Screens
DESIGNER: Michel Bouvet
PHOTOGRAPHY: Marc Garanger

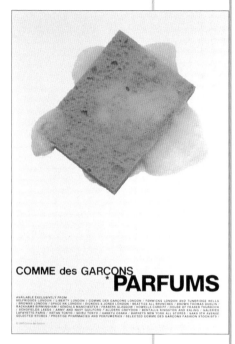

COMME des GARÇONS * PARFUMS

AVAILABLE EXCLUSIVELY FROM
SELFRIDGES LONDON / LIBERTY LONDON / COMME DES GARÇONS LONDON / FENWICKS LONDON AND TUNBRIDGE WELLS
BROWNS LONDON / SPACE NK LONDON / DICKENS & JONES LONDON / BEATTIES ALL BRANCHES / BROWN THOMAS DUBLIN
RACKHAMS BIRMINGHAM / KENDALS MANCHESTER / FRASERS GLASGOW / HOWELLS CARDIFF / HOUSE OF FRASER THURROCK
SCHOFIELDS LEEDS / ARMY AND NAVY GUILFORD / FRASERS GLASGOW / BENTALLS KINGSTON AND EALING / GALERIES
LAFAYETTE PARIS / ISETAN TOKYO / SEIBU TOKYO / HANKYU OSAKA / BARNEYS NEW YORK ALL STORES / SAKS 5TH AVENUE
SELECTED STORES / PRESTIGE PHARMACIES AND PERFUMERIES / SELECTED COMME DES GARÇONS FASHION STOCKISTS /

Poster for Comme des Garçons
DESIGNER: Marc Atlan

Package design for L'Oréal
DESIGNER: Marc Atlan

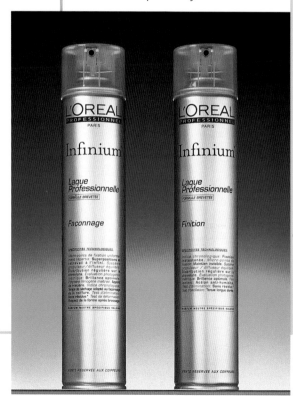

thought to the aesthetics of this major area of French communications design, of which he and many other Paris-based graphic designers are award-winning practitioners.

Bouvet has said that he believes a poster "can be at once avant-garde and popular." In an interview marking a decade of his work for the Maison des Arts de Créteil, a cultural-affairs organization just outside Paris, he observed: "When you deal with a subject like a festival in a town, you have to touch everyone without forgetting the place's soul and its culture. You can do new, intelligent things and [still] meet the public."

Bouvet believes that a designer—sometimes referred to, in French, as a *créateur* (creator) or an *auteur* (an author, in the fullest sense) of a work—has a responsibility to communicate in an interesting, stimulating, effective way, and that his or her work should be both "pedagogical and artistic" to help cultivate an appreciation of good design. At the same time, like many of the talents featured in this volume, Bouvet feels that, "Behind a poster, there's a poster artist whose work is the expression of a life."

Certainly there is plenty of room in French graphic design for the expression of many an individualistic auteur's vision, in everything from the avant-garde, conceptual minimalism of Marc Atlan's packaging and displays for the Japanese fashion label Comme des Garçons to the low-tech, morally minded work of Fabrice Praeger, who eschews complicated computer tools. "Too much thinking can kill action," Atlan once cryptically pronounced. "I don't consider myself a service provider, nor an artist. Anyway, it is not my place to judge."

On a daily basis, however, the public does have ample opportunity to consider the value and to evaluate the quality of graphic and other varieties of design in the built and visual

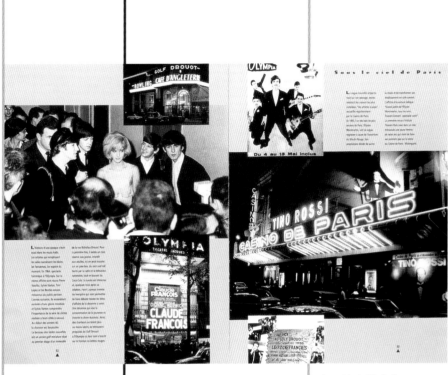

environments. Even the non-specialist visitor to France will soon notice the many systematic manifestations of design-mindedness that give shape and order to French cities, buildings, public services, and events, of which the Paris subway network—the legendary Métro—and the graphics that support it together may offer one of the most striking examples. (London's vast Underground and its familiar graphic-design program arguably may be even easier to navigate and more legible, too, but each of these transport systems is enduringly emblematic of its respective city.)

Especially since the mid-1980s, well-planned corporate-identity and public-sector identity and signage systems have given visible expression to the Cartesian, rational,

Layout for La Vie En Rose
DESIGNER: Louis Brody

Poster for a rave
DESIGNER: Fabrice Praeger

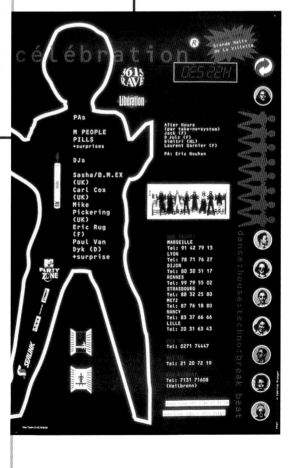

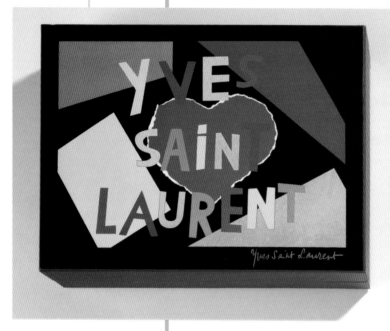

Yves Saint Laurent perfume box
DESIGNER: Didier Saco

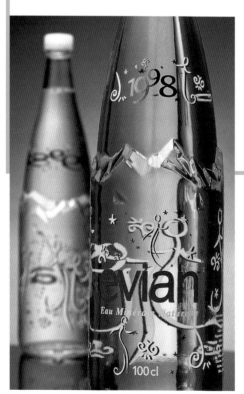

Bottle design for Evian
ART DIRECTOR: Béatrice Mariotti
CREATIVE DIRECTOR/ILLUSTRATION:
Laurence Puech

bureaucracy-loving streak that is the flip side of French culture's insouciant, Mediterranean *joie de vivre*. One sees it in the superbly coordinated, blue-and-yellow logo, signage, and publications of the national post office; in the thicket of logos that are always popping up for every new—and, often, for many an old—local, regional, or national organization; and in the neatly harmonized corporate-identity schemes, on-site signage, supporting publications, Web sites, or special-events graphics that are integral parts of the national railway system and its large stations, or of such institutions as the redesigned National Museum of Natural History and, of course, of the completely renovated Louvre in Paris.

Many Paris-based designers have become known through their work on such highly visible projects. In such cases, they have also

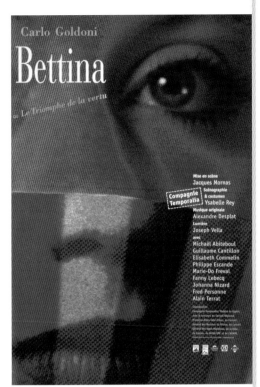

centralizing of activities and institutions that has been such a strong impulse administratively, but not always popularly, in France, despite the stated intentions of many a recent government to "decentralize" the traditionally Paris-centered nation.

Still, in spite of some official support for design, in the digitally driven nineties, on the eve of the new millennium, it is the rival British under Prime Minister Tony Blair, not the French, who have designated a cabinet-level minister to focus on design for commerce and industry. Many in France's creative community respect and admire the Blair government's appointment and what it signifies about the increasing importance of design in today's global economy and mass-media-linked culture. They also wish their leaders would take a similar step.

reaped the benefits of serving, directly or indirectly, the government as a client, insofar as such jobs may be supported in part by generous allocations from various national ministries. France's well-funded and influential Ministry of Culture, through its divisions that underwrite programs in the design arts, publishing, film, the theater, and other areas where graphic design figures prominently, plays an inestimable role as its patron. (Indeed, to land a job creating graphics for the ministry itself, for its own publications or events, is considered a plum assignment.)

Moreover, with its graphics, the Ministry of Culture boosts the kind of branding, organizing, identity-enhancing functions that graphic design at its best performs so naturally and well, whether for a small, local dance troupe or a nationwide book-appreciation campaign. In this way, this important government agency may be seen as effectively encouraging the

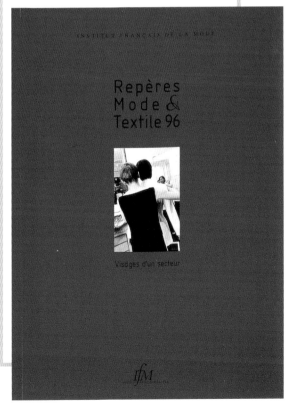

Poster commemorating a World War II battle
DESIGNERS: Nous Travaillons Ensemble

Compared to the design communities of Tokyo, Paris, New York, or even London, that of Paris seems relatively small. As designer Didier Saco, whose work for well-known French fashion designers is included in this book, points out, "Many of us know each other and many of us share the same clients, too." Even more than in some other design centers, one gets the impression that, in Paris, many a designer-client working relationship is deep and long-lasting. The fact that numerous Paris *ateliers,* or design studios, tend to be small operations driven by the very personal artistic visions of one principal or of a close-knit team of *collaborateurs,* like Nous Travaillons Ensemble, may help to explain the special intimacy that emerges between the graphic designers featured here and the clients whom they serve. So, too, perhaps, may these designers' insistence on expressing their strong artistic voices even though they recognize the value of and often employ the tools of up-to-the-minute marketing in their work.

Members of the design team that calls itself Thérèse Troïka say that, for them, "the essential thing" is to always be "in

fête des associations 24 juin 95 square Stalingrad Aubervilliers

Aubervilliers community poster
DESIGNERS: Nous Travaillons Ensemble

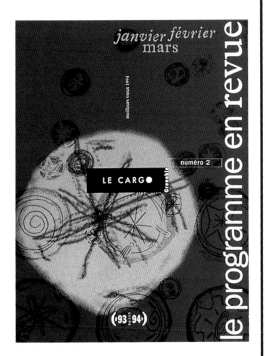

bring to their work—for the problem solving that lies at the heart of their task and for the predictable unpredictability of the creative process.

That passion, along with imagination and talent, is visible in the varied, wide-ranging, and innovative selections from the portfolios of the Paris-based graphic designers and design studios that have been brought together in these pages. To examine them is to appreciate, in a very special form, something of the distinctive energy and creative spirit that are so much a part of Europe's great capital of the arts. Steeped in tradition, this is graphic design that is forging ahead, unabashedly but eloquently, defining new and powerful forms on its own confident terms.

osmosis"—that is, closely in touch—with their clients' needs and aspirations, with the institutions and the people in charge of them for whom and with whom they work. A good example is Le Cargo, an arts center in Grenoble for which Thérèse Troïka has produced numerous posters and other graphics.

The fact is, of course, that even the most independent-minded design, if commissioned to serve a client's need, is to some degree a collaborative effort—and that most designers savor the creative give-and-take that brings a thumbnail sketch on the back of a napkin forward to become a national advertising campaign, a complete line of packaged goods, or a ground-breaking exhibition design in the hallowed galleries of the Louvre. What so many of the designers featured in this book speak about unhesitantly is the combined sense of commitment and passion that they

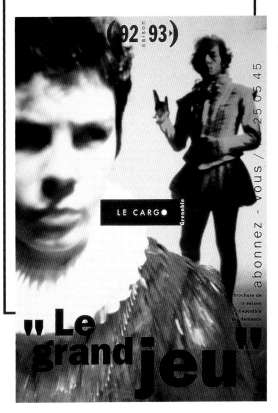

PRINCIPAL: Philippe Apeloig
FOUNDED: 1989
NUMBER OF EMPLOYEES: 3

12, cité Griset
75011 Paris
TEL (33) 1-43.55.34.29
FAX (33) 1-43.55.44.80

Much-watched among contemporary French graphic designers, Philippe Apeloig undertook a two-year internship at Total Design in Amsterdam after studying at the École Nationale Supérieure des Arts Appliqués and at the École Nationale Supérieure des Arts Décoratifs in Paris. In the mid-eighties, Apeloig went on to design the visual-identity scheme in posters, books, and other applications for the new Musée d'Orsay in Paris. Later, on a French government grant, he spent a year studying in Los Angeles with April Greiman, who exposed him to American design principles and the power of the Apple Macintosh computer as a design tool. Apeloig is a dedicated typography specialist who has worked mostly for cultural clients—dance companies, museums, publishers, and arts festivals. "The text—typography—remains the basis of our work," he emphasizes. In addition to creating original typefaces, Apeloig is known for type treatments that are full of motion and for layout compositions that exude an avant-garde spirit reminiscent of experimental music or dance scores. His work assimilates everything from Dutch Constructivism and classic grid-based systems to concrete poetry and Minimalism.

PHILIPPE APELOIG

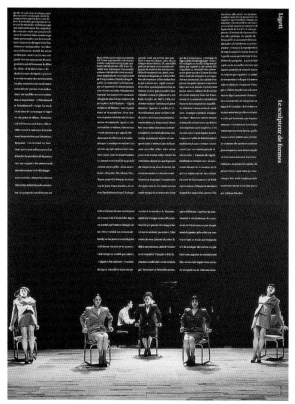
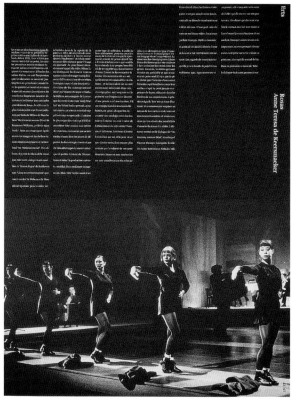

An organizational grid echoes the inherent rectilinearity of the artifacts depicted in a poster for the Louvre's renowned Egyptian antiquities collection.

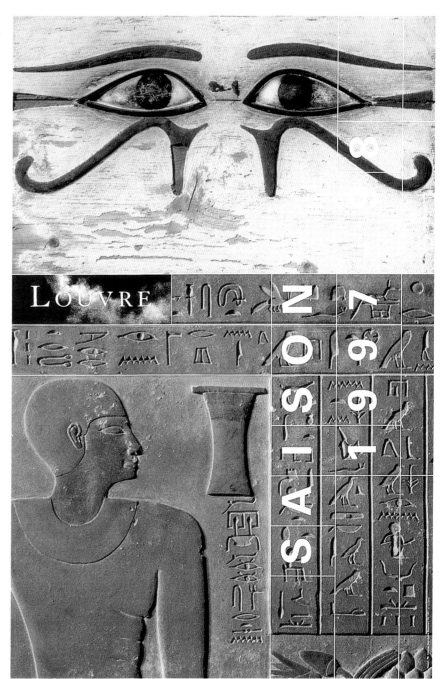

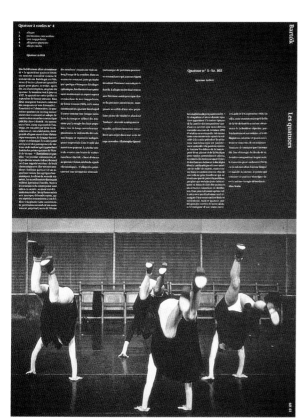

Layouts for a series program of modern dance and music-theater productions extend the depths of the stage space above the performers in the photos. White type is set against this blackness; the overall effect is one of crisp, cool, contemporary elegance.

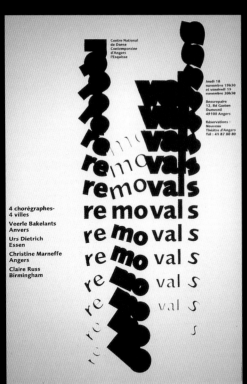

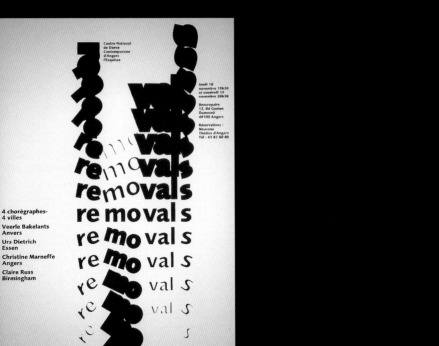

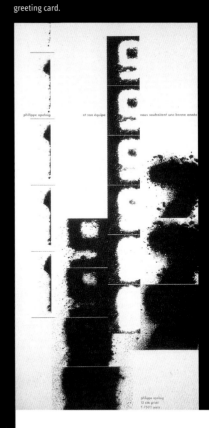

Photographs of numerals create
a rhythmic graphic pattern for
Apeloig's own 1997 New Year's
greeting card.

Type in motion appears to
jitter and dance in this stark,
black-and-white poster for four
choreographers' productions
in four different cities.

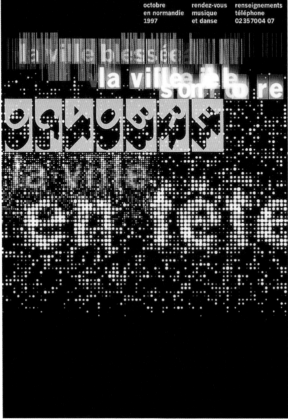

An effervescent type treatment
suggests the glittering lights of
a city at night in this poster for a
music-and-dance festival in
Normandy.

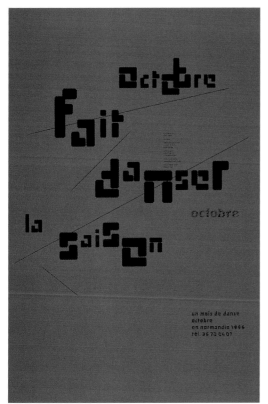

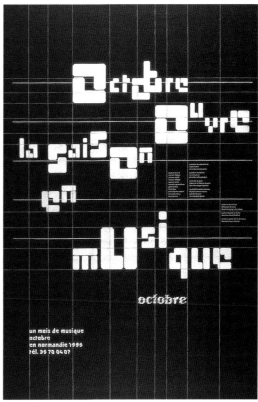

Sometimes less really is more, as in this red-and-black poster with an original Apeloig typeface that declares: "October makes the season dance." Its companion, also for a dance-and-music festival in Normandy, announces: "October opens the season with music." The first work uses a few scattered, splattered lines to evoke a sense of dancers' all-over motion; the hairline grid in the second poster alludes to musical notation and evokes a sense of music.

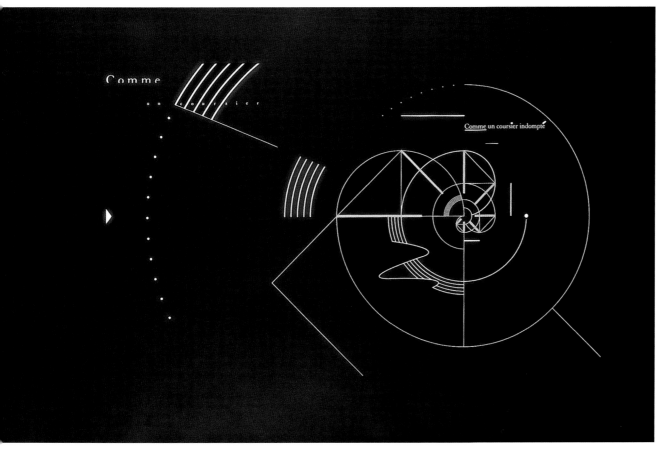

Planetary orbits, centrifugal forces, enigmatic mechanisms—ambiguous allusions proliferate in Apeloig's cover design for a book published to celebrate the bicentennial of the French Revolution.

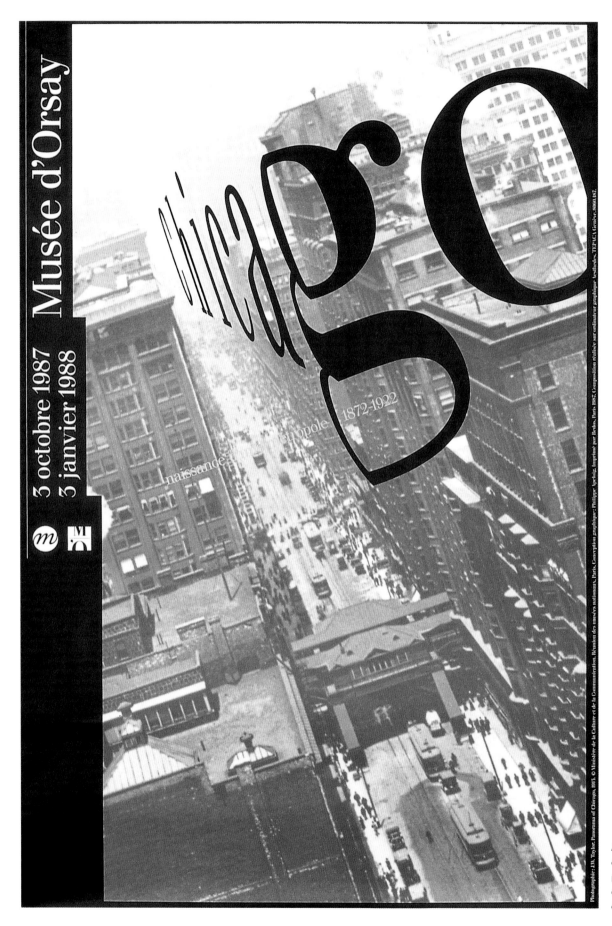

Apeloig's type treatment is emphatically dynamic in this poster for a Musée d'Orsay exhibition about the history of Chicago's growth.

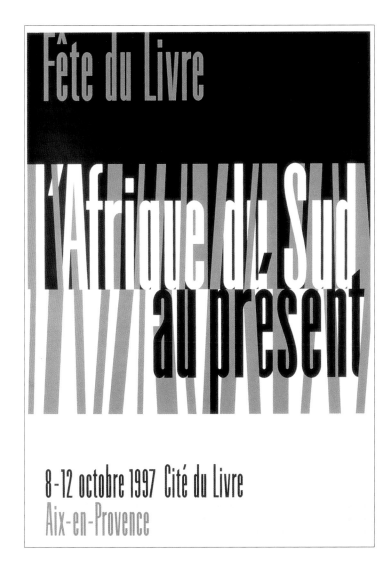

High-contrast design with
rhythmically moving, vertical
bars animates a poster for a
book festival focusing on
contemporary South Africa.

Faces from mummy cases,
mosaics and other masterworks
appear in this gridded compo-
sition calling attention, with
gentle visual humor and an
appropriately stately typeface, to
the Louvre's 1996–1997 season.

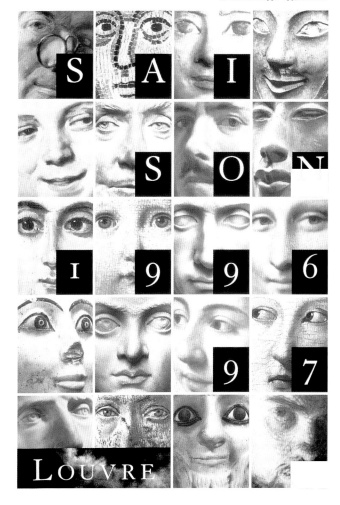

PRINCIPAL: Michel Bouvet
FOUNDED: 1989
NUMBER OF EMPLOYEES: 3

137, avenue de Choisy
75013 Paris
TEL (33) 1-45.85.75.81
FAX (33) 1-45.86.33.31

Trained as a painter, Michel Bouvet decided, after graduating from the École des Beaux Arts, to devote his talent to the art of the poster. Inspired by San Francisco's psychedelic-poster art of the sixties, and by the politically charged Czech posters of the Prague Spring, Bouvet has long been concerned with the role of the artist in society. Working in the French tradition of the *affiche culturelle*—literally, the "cultural poster"—which dates back to Henri de Toulouse-Lautrec's commercial art, Bouvet brings a painterly touch to eye-catching designs rich in visual puns and carefully chosen image-symbols. The apparent simplicity of his designs belies his habit of extensive research. For example, he once reread all of the Marquis de Sade's work for a single assignment. Bouvet exploits many media and techniques, including colored pencils, gouache, collage, reworked photocopies, photomontage, and hand-drawn lettering. He uses photography, too, and tends to favor dynamic images that both echo and reinforce the rhythmic quality that characterizes his work. Among other honors, Bouvet has twice received France's Grand Prix de l'Affiche Culturelle. His award-winning posters have been exhibited in solo and group shows around the world.

ATELIER MICHEL BOUVET

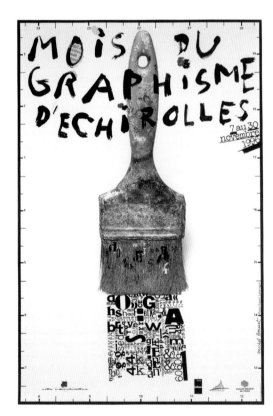

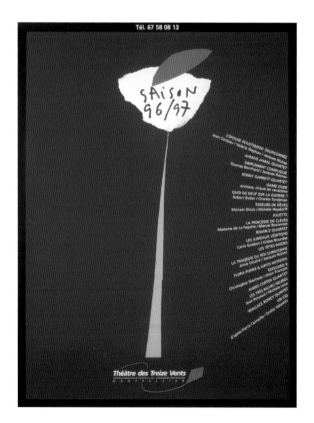

To celebrate the town of Echirolles' "Graphic Arts Month," Bouvet applies his wit with a broad brush.
PHOTOGRAPHY: Francis Laharrague

Intense primary colors, simple shapes, and a hand-jotted headline announce a season of the Théâtre des Treize Vents in this abstract Bouvet design.

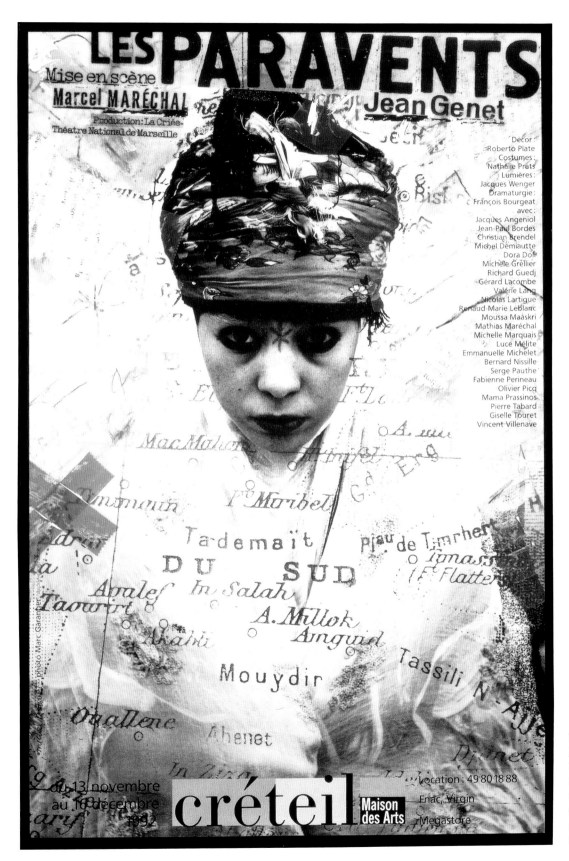

This poster for a production of Jean Genet's avant-garde play *The Screens* is full of multi-layered visual texture, despite its monochromatic tones, with a character's head that appears to pop out of a fragment of a map.

PHOTOGRAPHY: Marc Garanger

For the *Tower of Babel* poster
(a stage show presented by the
Institut International de la
Marionnette) Bouvet constructed
a symbolic tower of chicken
wire, electric cords, and other
modern detritus.
PHOTOGRAPHY: Francis Laharrague

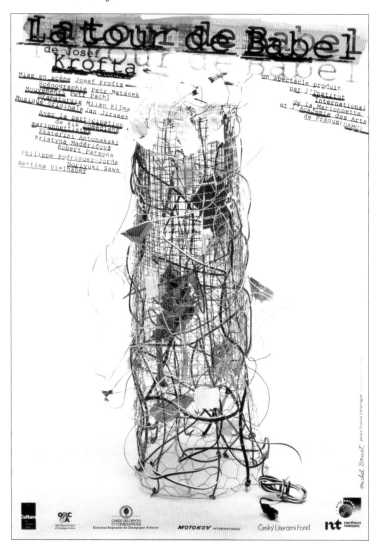

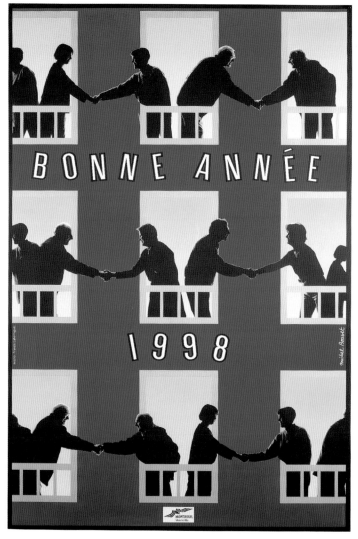

Bouvet employs bold colors and
silhouetted figures in this cheer-
ful New Year poster for the city of
Montreuil. Undulating letters sug-
gest a festive, hanging garland.
PHOTOGRAPHY: Francis Laharrague

A man's shaving brush becomes
an abstract bride in her wedding
gown for a presentation, in
Uruguay, of Mozart's opera
The Marriage of Figaro.
PHOTOGRAPHY: Francis Laharrague

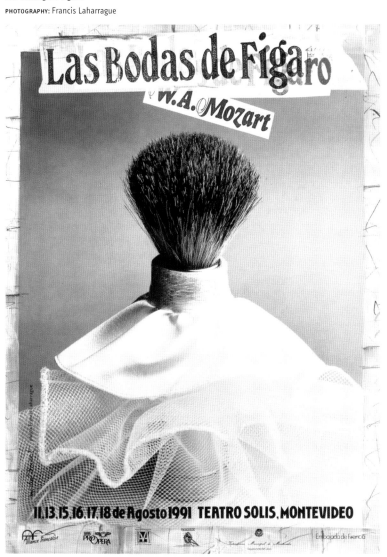

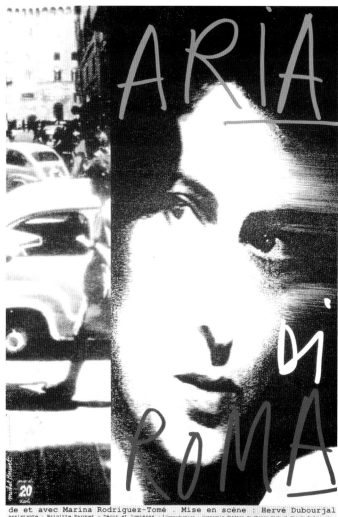

Carefully chosen and collaged
photographic images, with
hand-lettering in the colors of
the Italian national flag, lend
this poster for *Aria di Roma* an
appropriately impulsive air.

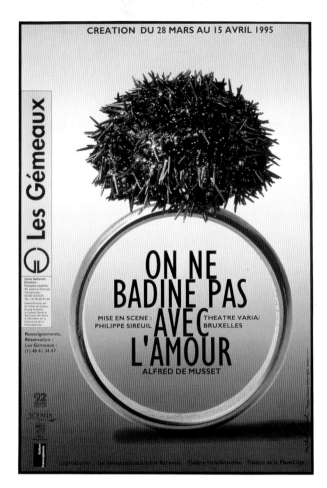

Bouvet is known for selecting emblematic images that suggest the central themes of the events for which he creates posters. For *On ne badine pas avec l'amour (One Doesn't Trifle with Love)* he chose a wedding ring, but in this trenchant visual pun, a prickly anemone takes the place of a precious gem.

PHOTOGRAPHY: Francis Laharrague

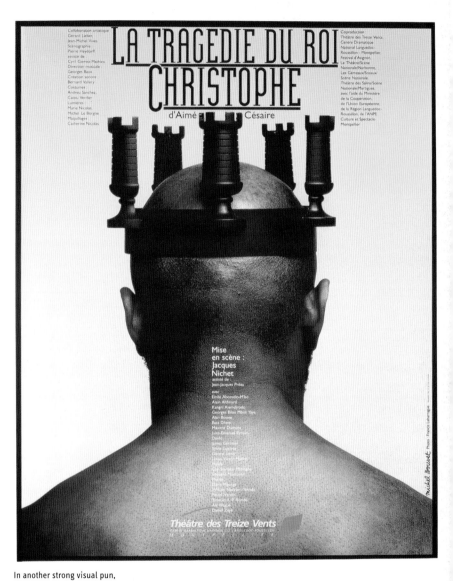

In another strong visual pun, for the play *La tragédie du roi Christophe (The Tragedy of King Christopher)*, turrets of the king's castle become the points of his crown. In a subtle touch, the headline typeface's long serifs echo the towers' crenelated tops.

PHOTOGRAPHY: Francis Laharrague

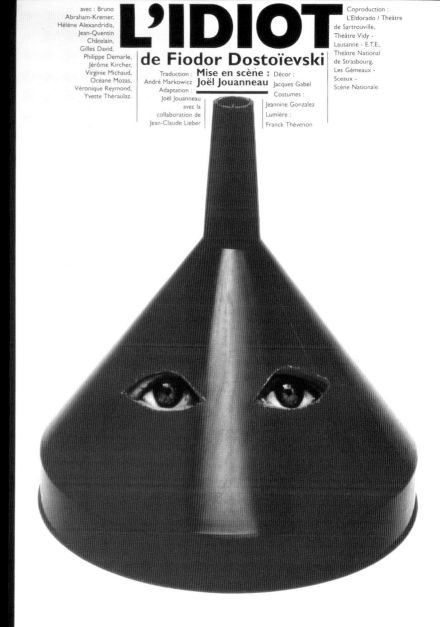

avec : Bruno
Abraham-Kremer,
Hélène Alexandridis,
Jean-Quentin
Châtelain,
Gilles David,
Philippe Demarle,
Jérôme Kircher,
Virginie Michaud,
Océane Mozas,
Véronique Reymond,
Yvette Théraulaz.

L'IDIOT
de Fiodor Dostoïevski

Traduction : **Mise en scène :** Décor :
André Markowicz **Joël Jouanneau** Jacques Gabel
Adaptation : Costumes :
Joël Jouanneau Jeannine Gonzalez
avec la Lumière :
collaboration de Franck Thévenon
Jean-Claude Lieber

Coproduction :
L'Eldorado / Théâtre
de Sartrouville,
Théâtre Vidy -
Lausanne - E.T.E.,
Théâtre National
de Strasbourg,
Les Gémeaux -
Sceaux -
Scène Nationale.

michel Bouvet Photo Francis Laharrague

Bouvet makes impressive use of
one of graphic design's perennially
powerful palettes—white, black,
and red—in this funny and unusual
poster for a stage version of
Dostoyevsky's novel *The Idiot*.

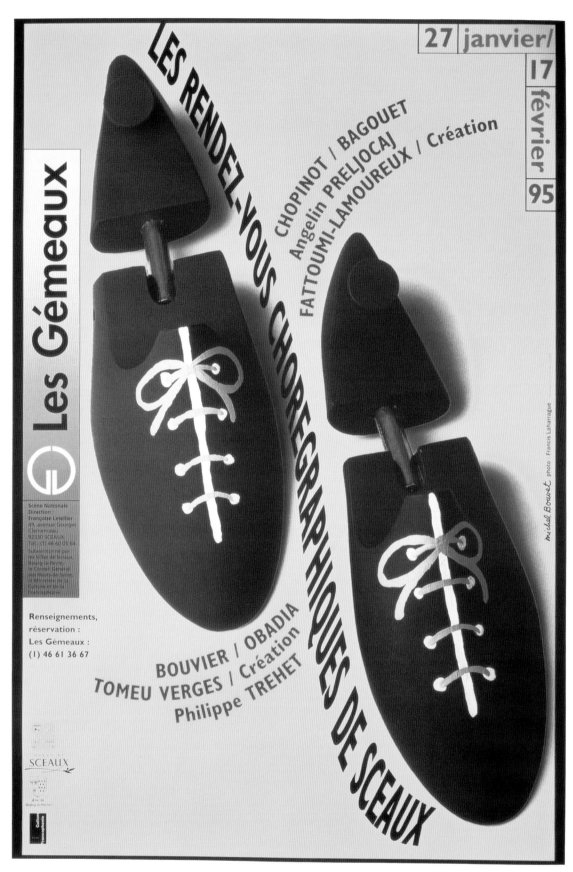

Once static, now painted, shoe trees become dancing shoes in this poster for a dance festival in France. Bouvet's bending, wraparound typography adds to the fun and rhythm of the animated design.

PHOTOGRAPHY: Francis Laharrague

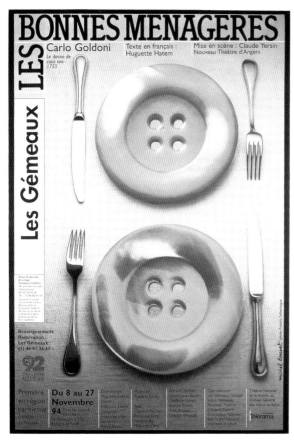

Simple, lively, effective visual
puns abound in Bouvet's work.
Here, tiny, plain garment buttons
become large dinner plates in
a poster for a French production
of Goldoni's play *The Good
Housewives*.
PHOTOGRAPHY: Francis Laharrague

The symbol of rock 'n' roll floats
against a colorful, spray-painted
background, advertising an
exhibition of guitars. The entire
composition, organized on a
grid, is tilted at an angle. White
dots underneath a four-line
headline subtly echo guitar
strings and fret dots.
PHOTOGRAPHY: Francis Laharrague

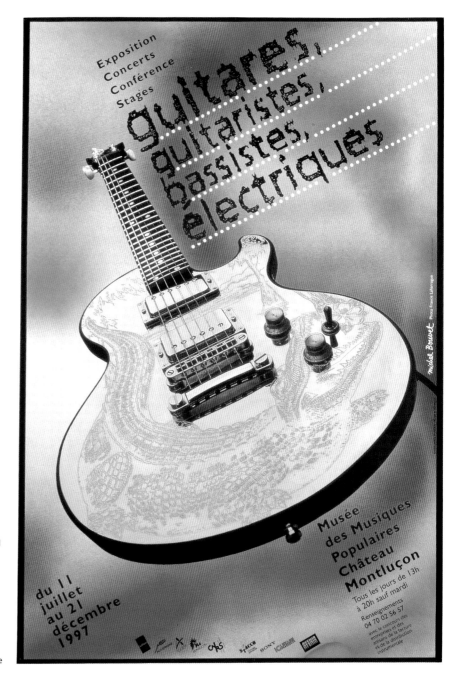

PRINCIPAL: Pascal Colrat
FOUNDED: 1988
NUMBER OF EMPLOYEES: 2

187, rue du Faubourg
Poissonnière
75009 Paris
TEL (33) 1-40.16.95.07
FAX (33) 1-45.96.08.90

A native Parisian, Pascal Colrat was born in 1964 and studied at the prestigious École Nationale Supérieure des Beaux Arts. Over the years, since completing his art-and-design studies, Colrat has come to specialize in the making of posters—*affiches culturelles*—for a wide range of cultural events presented at various venues around France. Often the productions for which he creates such promotional materials are co-sponsored in whole or in part by cultural organizations that are government-supported at the local, regional, or national level, a funding pattern that is common in France, where the arts are heavily subsidized. Colrat frequently creates the original photos that he uses in his work. He may employ strong visual puns, as in his politically and emotionally charged poster that addresses the Bosnia-Herzegovina crisis, or ambiguous, intriguing images like those that appear in his posters for numerous dance and theater companies.

ATELIER PASCAL COLRAT

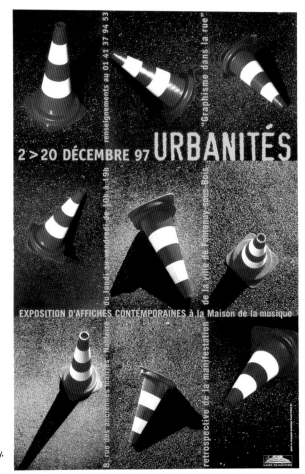

Colrat uses photographs of a traffic cone as a random pattern-making motif and an organizing grid of lines of type containing vital information in this poster for an exhibition of contemporary, urban-themed posters.

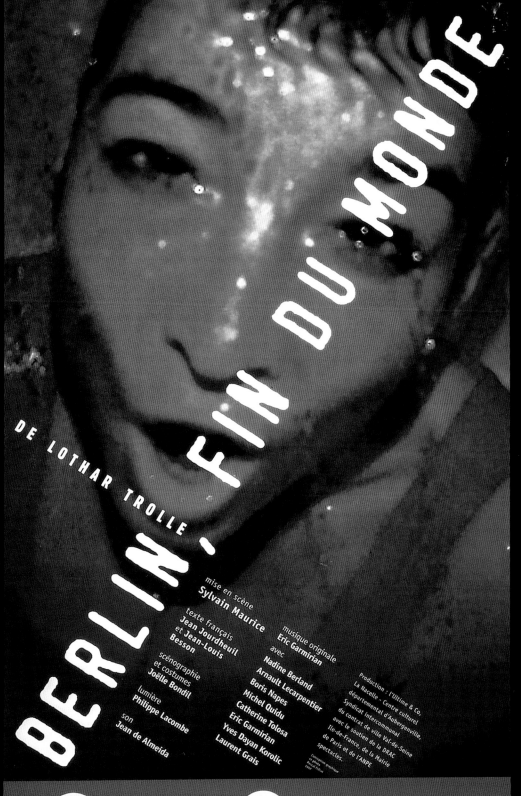

An intriguing photo close-up that Pascal Colrat himself produced and type laid out on strong diagonal axes energize this poster for *Berlin, End of the World*, a theatrical work.

BERLIN, FIN DU MONDE

DE LOTHAR TROLLE

mise en scène
Sylvain Maurice

texte français
**Jean Jourdheuil
et Jean-Louis
Besson**

scénographie
et costumes
Joëlle Bondil

lumière
Philippe Lacombe

son
Jean de Almeida

musique originale
Éric Garmirian

avec
**Nadine Berland
Arnault Lecarpentier
Boris Napes
Michel Quidu
Catherine Tolosa
Éric Garmirian
Yves Dayan Korolic
Laurent Grais**

Production : l'Ultime & Co.
La Nacelle - Centre culturel
départemental d'Aubervilliers,
Syndicat intercommunal
du contrat de ville Val-de-Seine
avec le soutien de la DRAC
Île-de-France, de la Mairie
de Paris et de l'ANPE
spectacles.

Conception graphique
et photo
Pascal Colrat
1997

du (7) janvier au (16) février à l'Atalante

location **01 46 06 11 90**

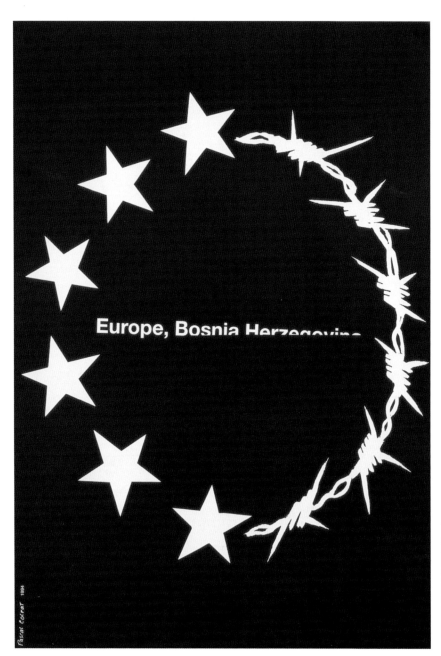

Europe, Bosnia Herzegovina

Powerful visual puns and a stark, black-and-white palette are the main ingredients of Colrat's anti-war poster and postcard inspired by the ongoing crisis in Bosnia-Herzegovina.

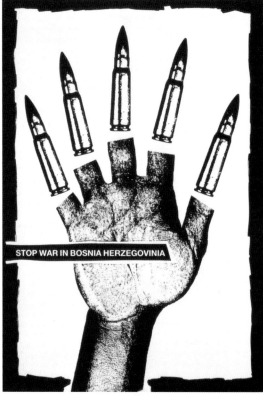

STOP WAR IN BOSNIA HERZEGOVINIA

Mysterious, attention-grabbing photographic images appear in many of Colrat's posters, such as these for *Ulysses,* a play adapted from *The Odyssey,* by Homer, and for a show of contemporary dance and juggling.

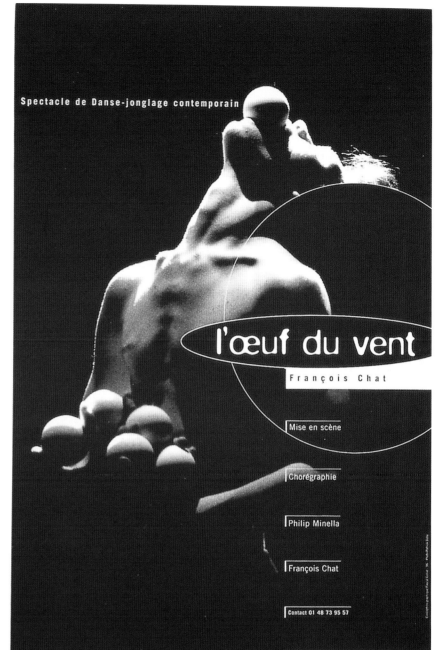

Spectacle de Danse-jonglage contemporain

l'œuf du vent

François Chat

Mise en scène

Chorégraphie

Philip Minella

François Chat

Contact 01 48 73 95 57

COPRODUCTION S'IL-VOUS-PLAÏT THÉÂTRE DE THOUARS

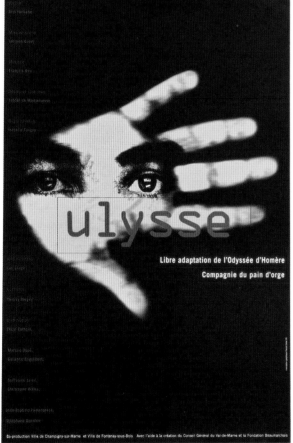

ulysse

Libre adaptation de l'Odyssée d'Homère
Compagnie du pain d'orge

MARC PATAUT

Nicolas FRÉMIOT

Philippe GUILVARD

Brigitte OLIVIER

Camille CUISSET

Bruno MAESTRONI

PHOTOGRAPHIES

enfantillages

26, RUE GÉRARD PHILIPE FONTENAY SOUS BOIS

2 ▶ 25 MAI 96 MAISON POUR TOUS

EXPOSITION

Chrystelle MORIN

Monique PROYART

Caroline POTTIER

Pascal Colrat

Les Affaires culturelles municipales de Fontenay-sous-Bois, AKTIS

A big diaper-pin motif and bold, complementary colors are the simple, eye-catching elements in Colrat's poster for an exhibition of photographs of and about children in Fontenay-sous-Bois, sponsored by the town's cultural-affairs office.

Chorégraphie
et mise en scène
Pierre Doussaint

Textes
**François
Cervantès**

Musique
**Jean-Paul
Buisson**

Costumes
**Laurent
Lamoureux**

VOX POPULI VOX

Scénographie
et lumières
Walter Pace

Colorful lightforms enliven
posters for two different dance
events and directly refer to the
movement of the human body.

PRINCIPAL: Marc Atlan
FOUNDED: 1990

46, rue de l'Arbre sec
75001 Paris
TEL (33) 1-40.15.92.40
FAX (33) 1-40.15.92.60

The conceptual is always clearly visible in the work of Marc Atlan, a young designer who is known for taking himself and his work very seriously—seriously enough to have trademarked his name. A seductive, slightly off-kilter air pervades much of Atlan's work and helps give its high-minimalist posture a kind of postmodern, quirky charm. Atlan studied at the École Supérieure de Design Industriel in Paris and did art direction for the magazine *L'Atelier* and image-development graphics for Cartier International. His big break came in 1994 when, after sending a letter to individuals he admired at record, fashion, and luxury-goods companies, and at various museums, Japan's hyperhip fashion designer Rei Kawakubo responded and hired him to create packaging for her Comme des Garçons fragrances. That assignment grew in scope, and today

Atlan is responsible for all of the fashion label's packaging and related materials for its markets outside Japan. "Too much thinking can kill action," Atlan has famously remarked. Thus, his work can be at once audacious and poetic; to launch the company's perfume at the Ritz Hotel in Paris, he made a display of clear plastic bags imprinted only with the Comme des Garçons logo and filled each one with the precious amber liquid. And for L'Oréal hairsprays, he came up with sleek cans that would look right at home aboard a spaceship.

MARC ATLAN

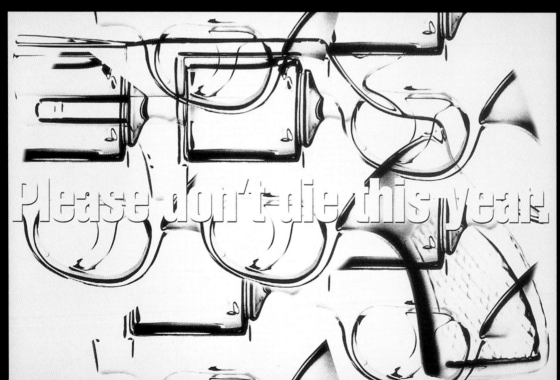

Please don't die this year

Atlan's graphic design and art direction for an art piece shown at the American Center in Paris features overlapping, ghost-like images of handguns

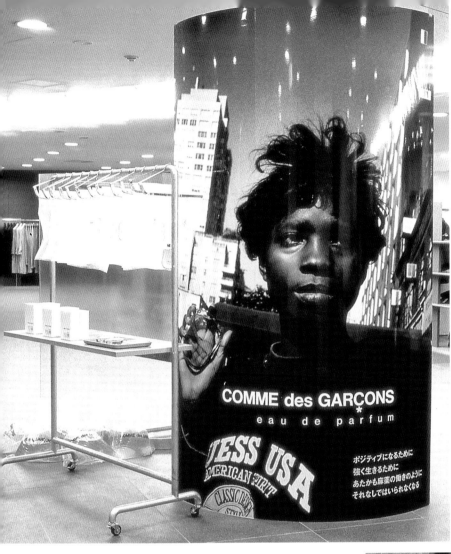

COMME des GARÇONS
*
eau de parfum

ポジティブになるために
強く生きるために
あたかも麻薬の働きのように
それなしではいられなくなる

Atlan's store displays for the
Tokyo launch of a Comme des
Garçons perfume featured
clear-plastic bags of the precious
liquid imprinted only with the
fashion label's logo.

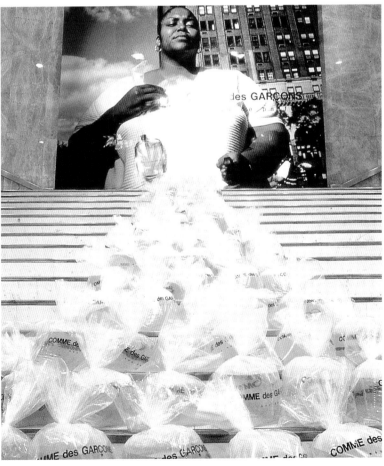

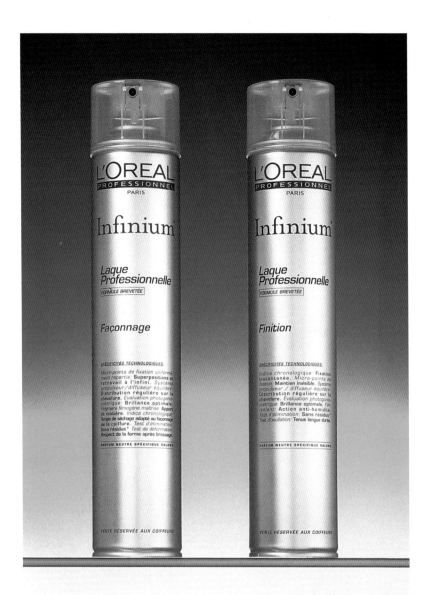

These sleek cans for L'Oréal hair-sprays resemble equipment from a spaceship. Atlan knows that looks imply meanings, and by introducing industrial plainness into the context of luxury-goods packaging, he effectively subverts our expectations of how such packaging can and should appear.

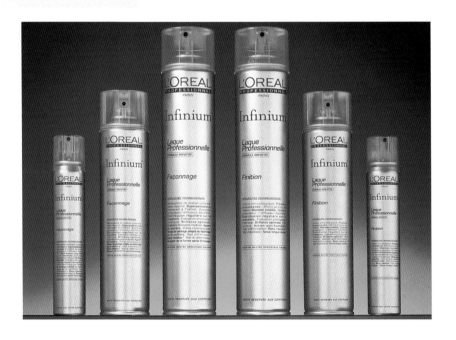

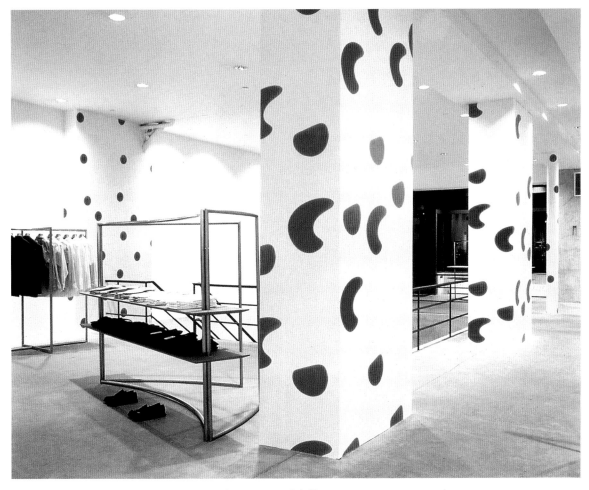

Japanese avant-garde fashion
designer Rei Kawakubo
commissioned this installation
work from Atlan for her Comme
des Garçons label's New York
boutique in 1993.

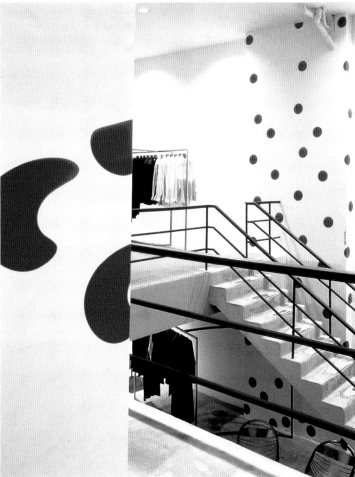

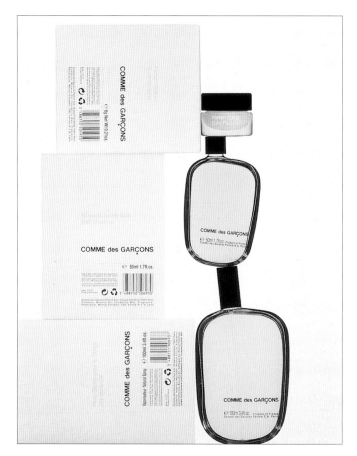

No-frills, austere minimalism meets hyperhip fashion chic in Atlan's packaging designs for the Japanese Comme des Garçons label's cosmetics. His plain, black-on-white boxes with little more than a logotype and barcode won *I.D.* magazine's 1995 award for best packaging design; in this series, unexpectedly off-center bottlenecks give ostensibly modest containers for pricey products a postmodern, quirky charm.

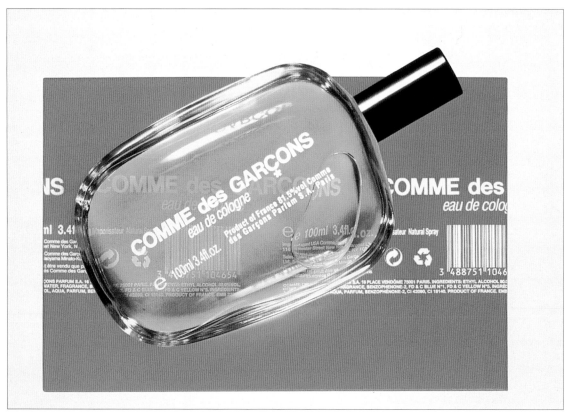

e 50ml. 1.7fl.oz.

COMME des GARÇONS white
EAU DE TOILETTE

80%VOL

COMME DES GARÇONS PARFUM S A PARIS

Product of France

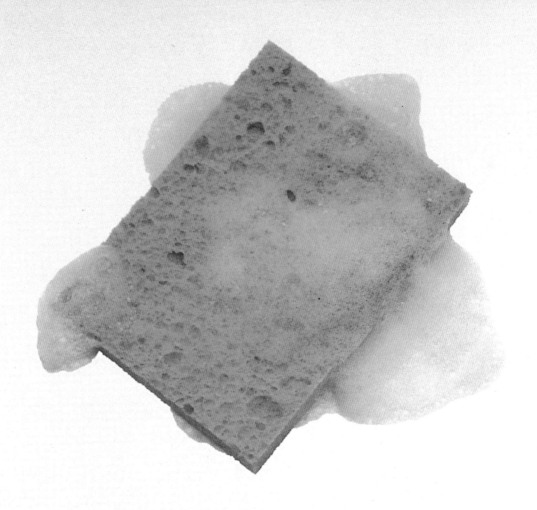

COMME des GARÇONS
*PARFUMS

Simplicity is beauty—and makes for luxurious irony, too, as in this stark ad image featuring an ordinary kitchen sponge and suds. The product: Comme des Garçons perfume.

Self-Promotion.

As a self-promotional piece to document and describe his work, Atlan created a small, metal-ringed binder that holds fold-out pages. Each loose-leaf insert serves as a dossier summarizing, in brief texts and in images, Atlan's concepts and executed projects, as well as some unrealized designs. This format allows him to send client-recipients updated pages to add to their copies of the book.

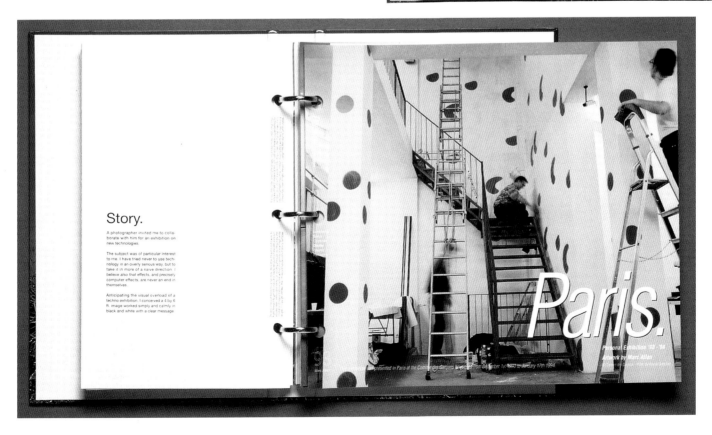

PRINCIPALS: Thierry Charbonnel, Patrick Poisson
FOUNDED: 1994
NUMBER OF EMPLOYEES: 1

132, rue Blomet
75015 Paris
TEL (33) 1-45.31.29.29
FAX (33) 1-53.68.90.50

Creative director Thierry Charbonnel and art-and-design director Patrick Poisson founded Autre, planètes. in the belief that, although in recent years many graphic designers have begun to offer Web site-related services, few have fully understood the practical-strategic implications of designing—and, most importantly, of maintaining— clients' sites. Autre, planètes. positioned itself early on the World Wide Web; technically and aesthetically, the studio has evolved right in step with rapid developments in the Internet and its culture. Charbonnel and Poisson recognize that it is no longer effective to distinguish between graphic designers on the one hand and programmers on the other; rather, they bring a combined understanding of the artistic and the technological to their work. In their Web sites for banks, newspapers, cultural institutions, and other clients, the Autre, planètes. team has done more than merely devise cursory public-relations material for already known companies or organizations. Instead, they have created fully functioning, multi-faceted annexes or extensions of each one that reflect and amplify their client-sources while also offering an information-rich, service-oriented experience that is uniquely their own.

AUTRE, PLANETES.

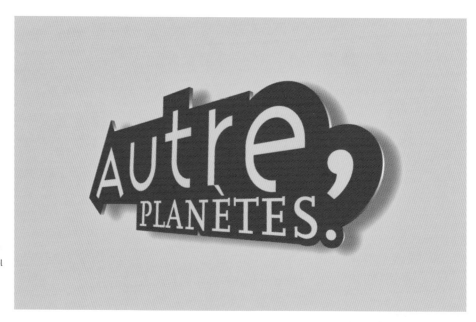

The studio's own logo captures something of the dynamic energy that motivates Thierry Charbonnel and Patrick Poisson, artist-technicians who specialize in Web-site design.

For a serious client like Crédit Lyonnais, the huge bank, the Web-site pages created by Autre, planetes. are colorful, attractive,

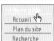

Accueil
Plan du site
Recherche

Les jeunes à l'IMA

الأطفال في المعهد

Activités jeunes

Lieu d'accueil pour les jeunes, l'IMA propose de nombreuses activités de découverte du monde arabe à son jeune public en individuel ou en groupe.
En liaison avec les expositions, le jeune public est invité à participer à des animations artistiques mises en place avec des artistes contemporains.
Une programmation Jeunesse autour de la musique et du cinéma ponctue le calendrier culturel de l'IMA.
L'Espace Jeunes, doté d'un atelier et d'une médiathèque, accueille les enfants à partir d'un fonds Jeunesse autour d'animations et de cours de calligraphie arabe.

Les publications jeunesse et pédagogiques, en vente à la librairie, ainsi que les petits journaux des expositions présentent divers aspects des cultures du monde arabe. Richement documenté et illustré, le livret-Jeunes Regards sur la civilisation arabo-musulmane, invite le jeune visiteur à une exploration active du Musée qui présente, à travers plusieurs centaines de pièces, l'évolution du monde arabo-musulman, de la naissance de l'écriture jusqu'au déclin de l'empire ottoman. Le Petit Journal Jeunes N° spécial Les Clés de l'actualité de l'exposition Yémen, au pays de la reine de Saba (25 octobre 1997- 28 février 1998) accompagne le jeune visiteur dans la découverte de cette exposition. A travers plus de 500 oeuvres, ils y découvrent le pays de la myrrhe et de l'encens, les secrets de l'écriture sud-arabique et les mystères d'étranges statues d'albâtre.

L'exposition Les Fatimides, la fascination de l'Orient (28 avril - 6 septembre 1998), présente l'une des périodes les plus brillantes de la civilisation arabo-musulmane née avec la fondation du Caire en 969.

L'espace image et son permet une découverte du monde arabe par l'image et le son. La recherche en cabine se fait par thème et par pays dans un fonds de 12 500 images, 300 films et près de 600 heures de musique.

Le Centre de langue et de civilisation arabes propose des cours de langue arabe pour les enfants.

Image : P. Clément

IMA Retour à l'accueil Recherche par mots clefs Vos suggestions

Mauritanie موريتانيا

Panorama
Géographie
Repères chronologiques
Economie
Education
Indice de développement humain

Autre pays Go

various companies.

Right window content:

Les effectifs par direction

Le CEA est organisé en directions fonctionnelles, directions opérationnelles, instituts et directions de centre. Les directions fonctionnelles veillent à la cohérence des règles de fonctionnement et mettent leurs compétences au profit des directions opérationnelles et de centre. Les directions opérationnelles ont la responsabilité de l'exécution des programmes scientifiques et techniques. Les directions des centres civils apportent un soutien logistique commun aux unités implantées sur le site. A la Direction des applications militaires (DAM), les directeurs de centre assurent, à la fois, les responsabilités opérationnelles et celles du soutien logistique.

Effectifs au 31 décembre 1996

Direction des sciences de la matière	1 864
Direction des sciences du vivant	575
Direction des réacteurs nucléaires	1 876,5
Direction du cycle du combustible	1 447
Direction des technologies avancées	1 446
Institut de protection et de sûreté nucléaire	1 253
Institut national des sciences et techniques nucléaires	100
Direction de l'information scientifique et technique	110
Direction des applications militaires	5 190,5
Service technique mixte des chaufferies nucléaires de propulsion navale	21
Directions de centres civils	2 234
Directions fonctionnelles	540,5
TOTAL	16 609,5

PRINCIPAL: Louise Brody
FOUNDED: 1990

7, rue du Docteur Roux
75015 Paris
TEL (33) 1-40.65.08.52
FAX (33) 1-40.65.08.66

British-born Louise Brody has worked in England, Singapore, and Italy, and is now based in Paris, where she specializes in book and periodical design. From Paris, she has served as the art director/designer of fine-quality books produced by a variety of leading French and British publishers, and for such French government agencies or government-supported institutions as the Ministry of Foreign Affairs and the Pompidou Center. Brody approaches her work with a concern for what the French call the *mise en page*. As in the theater's *mise en scène*, this concept views the page as a kind of staging area for visual information, in which graphic elements—text blocks, images, color, shapes—are arranged and presented, and in which, in their own ways, they

perform. Brody's lively spreads for the book *La vie en rose* (Éditions Plume, 1997) use both vintage black-and-white photographs and state-of-the-art page layouts to evoke the spirit of the legendary cabaret and music-hall age; her regular designs for publications like *Le Journal des Arts* offer straightforward solutions for hard-working, information-packed pages.

LOUISE BRODY

Silhouetted photographs help animate an information-packed page from *Vernissage*, a supplement of *Le Journal des Arts*.

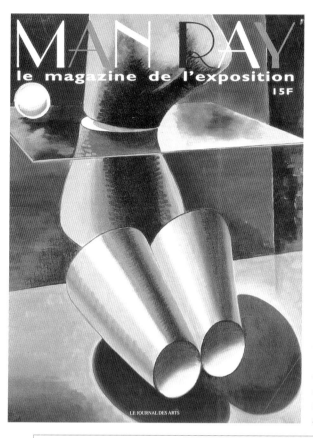

A booklet published by *Le Journal des Arts* served as a guide to an exhibition of Man Ray's work. Here, Brody employed Deco-ish display type and thick, vertical dividing lines to evoke the historic era of early Surrealism and help organize pages.

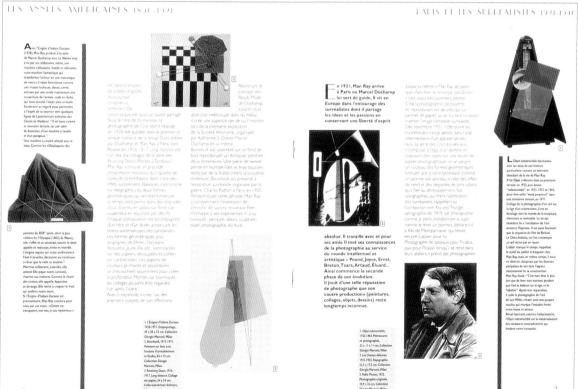

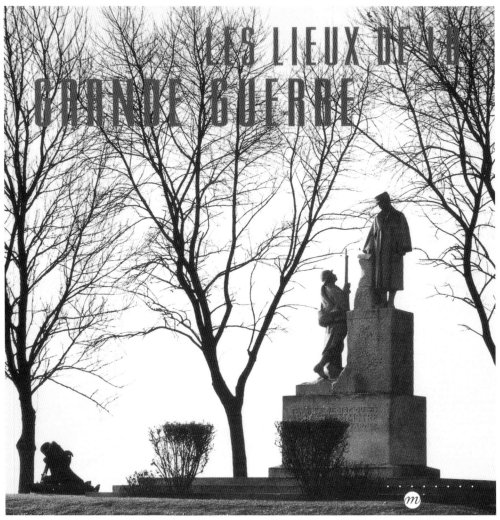

Warm-toned, vintage black-and-white photographs and colored headline type on the cover and section-divider spreads lend an appropriately solemn character to a book about World War I published by France's national museums. Brody conceived and executed the design.

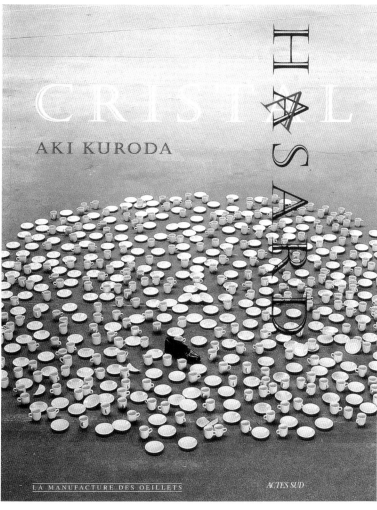

The catalog cover's spinning, overlapping letter *A*, and a playful handling of type inside, enliven this design—in keeping with the spirit of the edgy contemporary art by Aki Kuroda that the publication documents.
PHOTOGRAPHY, COVER: Julien Célice.
PHOTOGRAPHY, INSIDE SPREAD: Johannes von Saurma;
PUBLISHER: Actes Sud, 1997

La Bohème

A well-chosen display type and bold background colors bring the golden age of *chanson* to life in these layouts for the pop-music book *La vie en rose*.

PUBLISHER: Éditions Plume

Édith Piaf et l'amour

Brody brings clarity and legibility to the task of setting up effective, flexible layout schemes for information-packed, text-dense pages.

À l'occasion de la Fiac, un Vernissage sur la situation de l'art contemporain en Suisse

LE JOURNAL DES ARTS

L'ACTUALITÉ DE L'ART ET DE SON MARCHÉ À TRAVERS LE MONDE

Paraît un vendredi sur deux / N° 44 / 26 septembre 1997

25FF/175FB/175LUF/8CHF/1000PTE/L8500/800ESB/CAN$ 7/US$5

Georges de La Tour : le débat est relancé

Événement phare de la rentrée, l'exposition "Georges de La Tour" est la première depuis 1972. Avec la quasi-totalité des œuvres connues, ainsi que des gravures anciennes, le Grand Palais fait le point sur vingt-cinq années de recherches, de découvertes et de débats sur l'artiste le plus mystérieux de l'après-Renaissance. Sa vie reste un mystère, aucun témoignage, aucune biographie ne sont connus, des œuvres ont disparu, et la chronologie de celles parvenues à nous reste très difficile à établir.
Ci-contre : La diseuse de bonne aventure, détail
Lire page 6

Le Grand Palais enfin prêt pour le troisième millénaire

Catherine Trautmann va consacrer 400 millions de francs à des travaux d'urgence au Grand Palais, permettant sa réouverture en l'an 2000. De même, elle a donné son feu vert à la création attendue d'un Institut national d'histoire de l'art.

PARIS. Il y a quatre ans, la chute d'un petit boulon du dôme de la verrière du Grand Palais entraînait la fermeture du plus vaste espace d'expositions et de salons de la capitale. L'incident faisait prendre brusquement conscience de l'instabilité de l'édifice construit en 1900 côté Seine, il s'enfonçait d'un à deux millimètres par an. En juillet 1994, les Galeries nationales – où se tiennent actuellement les exposi-

tions Prud'hon et La Tour – rouvraient, mais rien n'était entrepris pour la grande nef où se déroulaient notamment la Fiac et la Biennale des Antiquaires. Le ministère de la Culture va financer des travaux pour la consolidation du bâtiment, pour le rouvrir en l'an 2000. Il est vraisemblable qu'il accueillera des manifestations marquant le nouveau millénaire, mais rien n'est encore arrêté. De même, rien n'est décidé pour son affectation future. Le dossier dépend de plusieurs ministères, comme celui du futur Musée de l'Homme, des Arts et des Civilisations, qui dépend de la Culture et de l'Éducation nationale. Pour Catherine Trautmann, "il n'est pas certain" que le "Musée des arts premiers" soit

implanté au Trocadéro, ainsi que l'avait proposé le gouvernement Juppé. De son côté, le ministre de la Défense, Alain Richard, a laissé entendre qu'il ne verrait pas d'un mauvais œil le report de l'ouverture du marché de la Marine pourrait rester à sa place car son transfert éventuel ne revêt pas "une extrême complexité". Catherine Trautmann a également donné son feu vert au projet de création d'un Institut national d'histoire de l'art (lire nos pages 2), piloté par Michel Laclotte, ancien président du Louvre. Comme prévu, celui-ci s'implantera dans l'ancienne Bibliothèque nationale et devrait regrouper universitaires, chercheurs, l'École du Patrimoine, celle des Chartes... Les travaux de réaménagement devraient eux aussi commencer l'an prochain et durer deux ans au maximum.

Sursis d'un an pour les commissaires-priseurs

Selon les informations du *JdA*, le gouvernement français souhaite retarder d'un an l'ouverture du marché de l'art aux sociétés étrangères, prévue au 1er janvier 1998. Il aurait demandé ce nouveau délai à la Commission européenne. Notre pays risque de se trouver dans un bel imbroglio juridique.

PARIS. La France semble avoir pris une habitude. Après une élection, le nouveau gouvernement demande à la Commission de Bruxelles un report de l'ouverture du marché de l'art. En 1995, après les présidentielles, le gouvernement Juppé avait fait une telle démarche et obtenu un sursis de deux ans qui a permis au garde des Sceaux de l'époque, Jacques Toubon, de préparer un projet de loi devant entrer en vigueur le 1er janvier prochain. Mais la dissolution de l'Assemblée nationale a tout bouleversé, et le projet n'a pas été déposé devant le Parlement. Le gouvernement Jospin aurait donc

fait la même demande, invoquant d'une part un calendrier parlementaire trop chargé et, d'autre part, le délai de deux mois nécessaires à la rédaction des décrets d'application. Si la Commission acquiesce une nouvelle fois, ce qui n'est pas acquis, les commissaires-priseurs conserveraient leur monopole une année de plus.

"C'est immoral, la France a pris un engagement, elle doit le tenir", proteste Laure de Beauvau-Craon, président de Sotheby's France. *J'attends avec intérêt la réponse de la Commission".* En toute hypothèse, la maison américaine, qui avait déposé en 1995 une plainte contre le maintien du monopole, renforcera son implantation en France dès la fin de cette année en s'installant dans les anciens locaux de la galerie Charpentier, en face de l'Élysée. Christie's, qui doit reprendre les locaux de la librairie Artcurial, près des Champs-Élysées, s'abstient de tout commentaire. *"Plus on attend, plus c'est mauvais pour la restructuration du marché français, mais c'est incon-*

tournable à cause du calendrier parlementaire"*, estime de son côté le président de la Chambre nationale des commissaires-priseurs, Gérard Champin. La France risque de se trouver dans un bel imbroglio juridique. Le monopole est contraire au Traité de Rome, et l'engagement pris par Jacques Toubon au nom de la France a constitué une reconnaissance officielle de l'inexactitude des subtilités juridiques invoquées pour le maintenir. En conséquence, si un opérateur décide d'organiser en 1998 une vente volontaire aux enchères publiques, il aura clairement le droit pour lui...

Danaé restaurée

Douze ans après son attaque par un iconoclaste lituanien, la *Danaé* de Rembrandt sera de nouveau exposée dès le 14 octobre, au Musée de l'Ermitage à Saint-Pétersbourg. Une date attendue avec impatience par les conservateurs du musée et les autorités politiques. Un long débat les avait en effet opposés sur la restauration.

SAINT-PÉTERSBOURG. Le 15 juin 1985, un déséquilibré pénètre dans le Musée de l'Ermitage et lacère à coups de couteau la *Danaé* de Rembrandt, avant de l'asperger de vitriol. On croit le chef-d'œuvre perdu : l'acide a complètement détruit la partie supérieure de la

toile, et des coulures ont profondément endommagé sa partie inférieure. Après une intervention d'urgence, les travaux sont longtemps retardés, la restauration devenant une véritable affaire politique opposant l'Ermitage au Parti communiste. Ce dernier exige en effet que les dégâts soient entièrement masqués. Le musée obtient finalement gain de cause. La toile, qui sera la

Le tableau de Rembrandt après l'acte de vandalisme et après sa restauration

pièce maîtresse d'une exposition d'un an sur "Le dessin des chefs-d'œuvre de Rembrandt", est effectivement "peinte par Rembrandt, et non par le personnel du département de conservation de l'Ermitage", rassure un porte-parole du musée.

T 4815 - 44 - 25,00 F

PRINCIPALS: Gérard Caron,
Michel Alizard, Michel Disle
FOUNDED: 1973
NUMBER OF EMPLOYEES: France, 93;
Europe, 140

Square Monceau
82, boulevard des Batignolles
75850 Paris Cedex 17
TEL (33) 1-53.42.35.35
FAX (33) 1-42.94.06.78

Paris is home to branches of some of the world's most influential, multi-national advertising agencies, as well as to several noteworthy French advertising and public relations outlets with a pan-European or global reach. Like their counterparts abroad, these companies may maintain their own in-house design departments and also tap outside creative talent. Founded in 1973 by Gérard Caron, Michel Alizard, and Michel Disle, the Paris-headquartered Carré Noir network includes offices in New York, Tokyo, London, Torino, and Brussels. The company offers clients everything from product-development and brand-research services to product and packaging design, and the creation of comprehensive style manuals for the consistent usage of the logos and design materials that the firm creates. Often, the larger and more conventionally commercial an advertising company becomes, the less inventive its design work may start to appear over time as a sense of conservative corporate consciousness sets in. At its best, however, for all the marketing muscle that supports—and that inevitably helps shape—its designs, Carré Noir's work still surprises and delights a viewer with its polish and professionalism, and with its unselfconscious assimilation or exploration of new production techniques and aesthetic ideas. This can be seen in a wide-ranging portfolio, from Carré Noir's decorative, surface-textured glass bottles for Evian to its digital-era styling of a CD-ROM series for Canal+ Multimedia.

CARRE NOIR

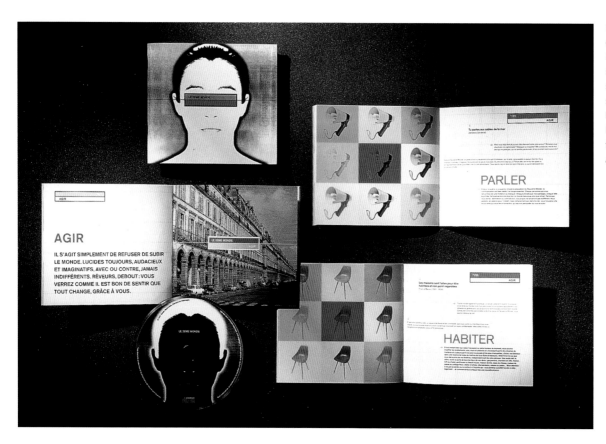

In Carré Noir's digital-era styling of a CD-ROM series for Canal+ Multimedia, manipulated head-shots on the CD covers complement similar images on the discs themselves. Inside the accompanying booklets, a visible organizing grid becomes a decorative as well as a functional device.
ART DIRECTOR: Andrew Pengilly

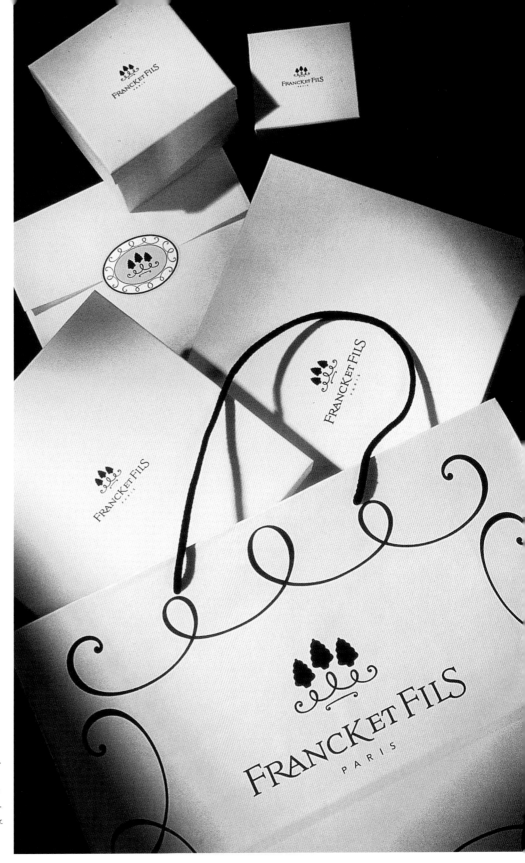

Carré Noir used a limited, yellow-and-black palette to achieve the glossy but understated character appropriate to the packaging system for an upscale Parisian retailer.

ART DIRECTOR/CREATIVE DIRECTOR:
Béatrice Mariotti

Carré Noir designed this
backpack-handbag and its
packaging in an attempt
to allow Delsey, a manufacturer
of hard-case bags and luggage,
to diversify its product line.
The eye-catching cardboard
holder's form emulates
that of the product's human
wearer-user.

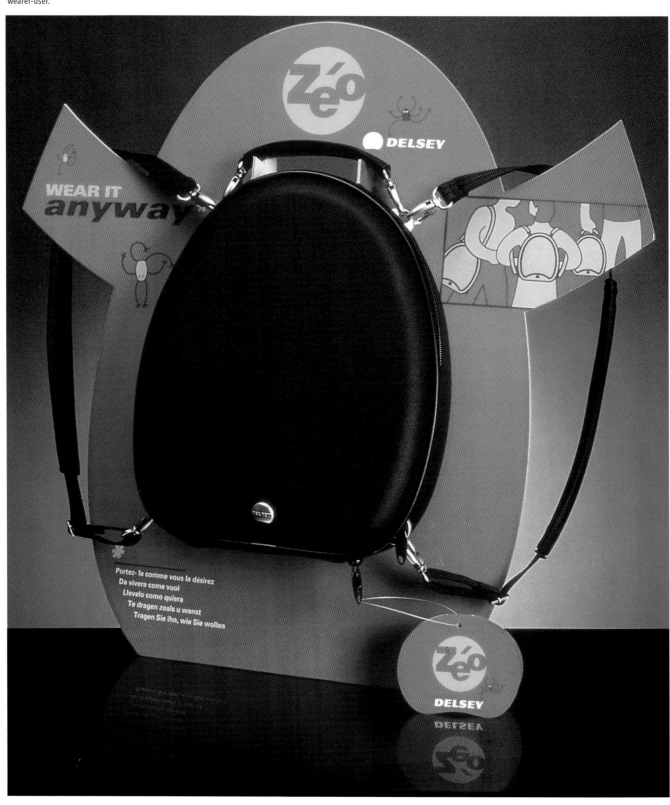

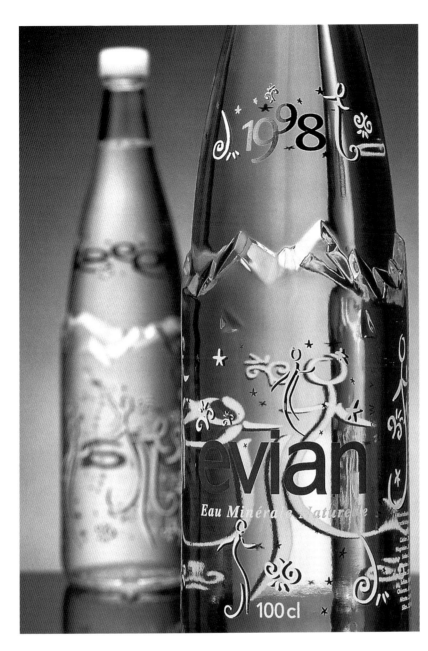

Carré Noir's limited-edition, surface-textured, and decorated glass bottles for Evian go on sale during the year-end/New Year's holiday season and become instant collectibles.

ART DIRECTOR: Béatrice Mariotti

CREATIVE DIRECTOR/ILLUSTRATOR: Laurence Puech

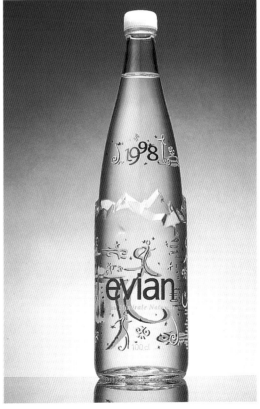

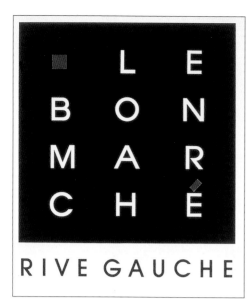

Carré Noir has created some of France's—and some of Europe's—most familiar corporate logos, such as the grid-based symbol for Le Bon Marché, whose solitary red square playfully echoes the red accent mark in the store's name. Here, shopping bag designs for some of the retailer's special promotions cleverly integrate the logo.

ART DIRECTOR/CREATIVE DIRECTOR:
Béatrice Mariotti

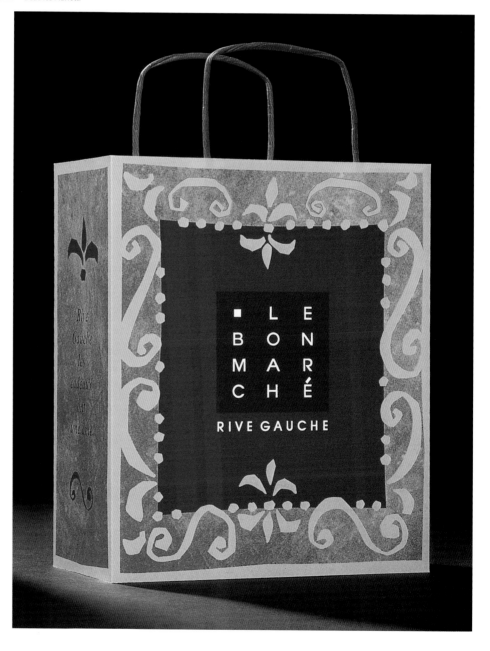

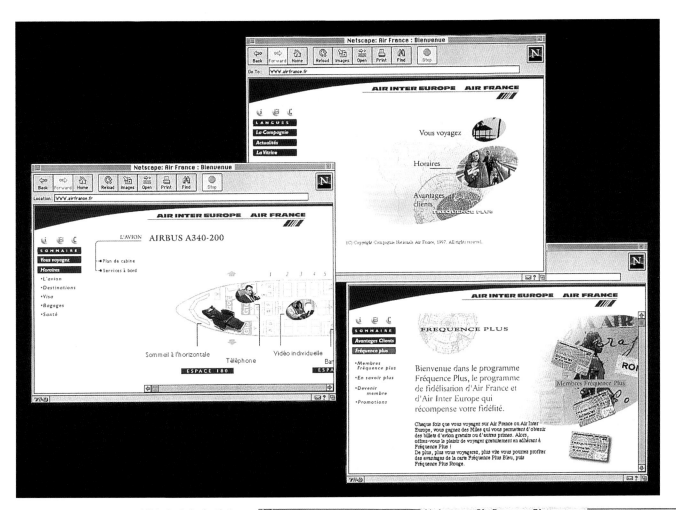

A Web-site design for Air France, emphasizing clarity and functionality, also demonstrates Carré Noir's easy command of the contemporary corporate vernacular.

ART DIRECTOR: Béatrice Mariotti

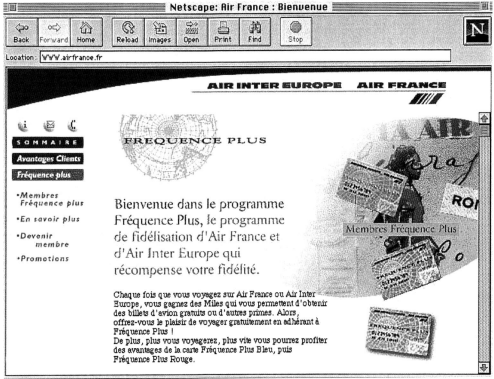

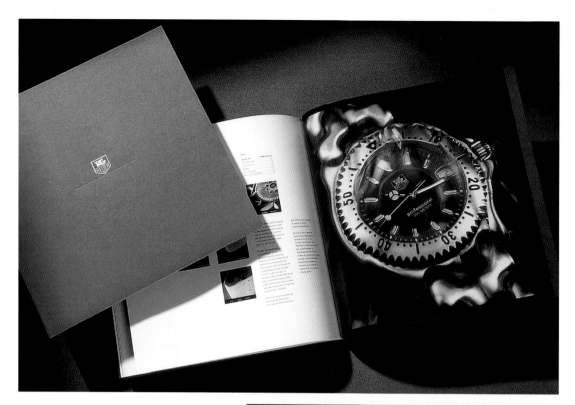

Ordinarily small, wristwatches
assume a monumental,
iconographic quality in these
layouts for a promotional booklet
for Swiss watchmaker Tag Heuer.
ART DIRECTOR: Andrew Pengilly
PHOTOGRAPHY: Robin Barton

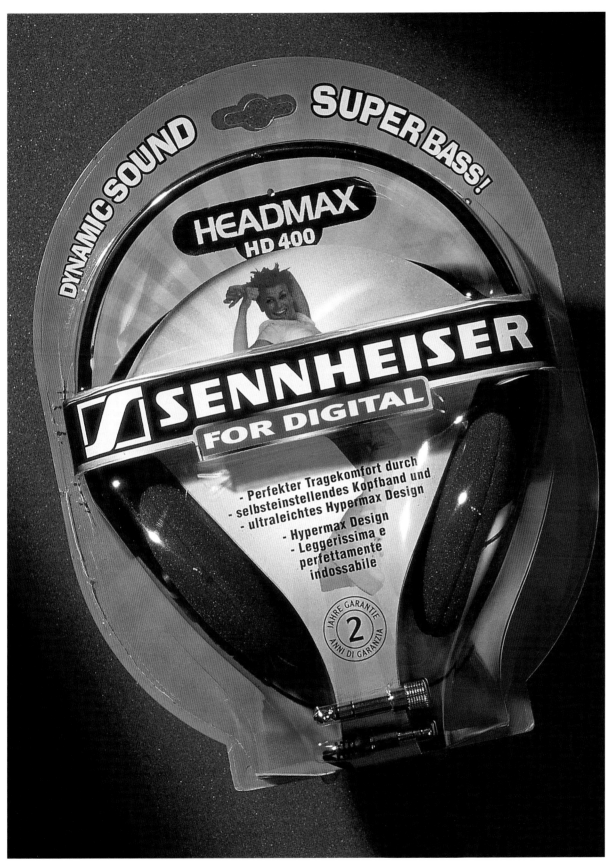

In redesigning form-fitting packaging for Sennheiser earphones, Carré Noir sought to heighten brand-name visibility. Its straightforward solution was to place the well-integrated name logo, like a target's bull's eye, in the center of the products' new packages.

ART DIRECTOR: Jean-Christophe Cribelier

CREATIVE DIRECTOR: Jérôme Maître

PRINCIPAL: Anne-Lise
Dermenghem
FOUNDED: 1988

7, rue Édouard Nortier
92200 Neuilly-sur-Seine
TEL (33) 1-47.38.29.05
FAX (33) 1-47.38.29.05

Anne-Lise Dermenghem specializes in packaging, graphic design for the publishing industry, and the development of logotypes and corporate-identity schemes. One of her biggest, longtime clients is the Association de Coordination Technique pour l'Industrie Agro-alimentaire (ACTIA), a government-funded network of applied-research centers around France that link agriculture to industry. For ACTIA, she has created annual reports, stationery, book covers, pamphlets, and other pieces whose light colors and gentle looks belie the concentration and weight of the technical data they contain. In much of this material, thematically, Dermenghem refers to nature as much as to technology, as in ACTIA's logo, which contrasts the fluffiness of a tree's leafy branches with the maze-like, rectilinear pattern of its deep roots. Dermenghem's work is especially marked by clarity. It offers a good example of the important role that graphic design plays in a country as centralized as France in establishing the identity and visibility of nationally known organizations.

ANNE-LISE DERMENGHEM

A simple birth-announcement card for the designer's own son, printed on textured, color-flecked paper, combines the gentle touch and elegance that are the hallmarks of Dermenghem's style.

ART DIRECTOR/CREATIVE DIRECTOR:
Anne-Lise Dermenghem

ROMAIN

est heureux de vous annoncer la naissance de son frère

JULIEN
31 JANVIER 1997

Anne-Lise Dermenghem & Didier Majou . 7, rue Édouard Nortier . 92200 Neuilly-sur-Seine

The sometimes gentle-feeling, monochromatic covers for spiral-bound reports published by ACTIA belie the concentration of technical data that they contain. The volume shown with its storage-box label hints at the density of the data inside.

ART DIRECTOR/CREATIVE DIRECTOR:
Anne-Lise Dermenghem

Convention

Recherche & Industrie alimentaire

construire l'avenir

Mercredi 17 juin 1998

ACTIA
Association de coordination technique pour l'industrie agro-alimentaire

ANIA
ASSOCIATION NATIONALE DES INDUSTRIES ALIMENTAIRES

GISRIA
Groupement d'intérêt scientifique recherche industrie alimentaire

Association nationale des industries alimentaires

Amphithéâtre Louis Armand
Centre des Congrès de La Villette
Cité des Sciences et de l'Industrie
30, avenue Corentin-Cariou
75019 Paris

Dermenghem carries her blue-dominated palette over into various pamphlets for ACTIA, as in these versions of an announcement for the organization's convention.

ART DIRECTOR/CREATIVE DIRECTOR:
Anne-Lise Dermenghem

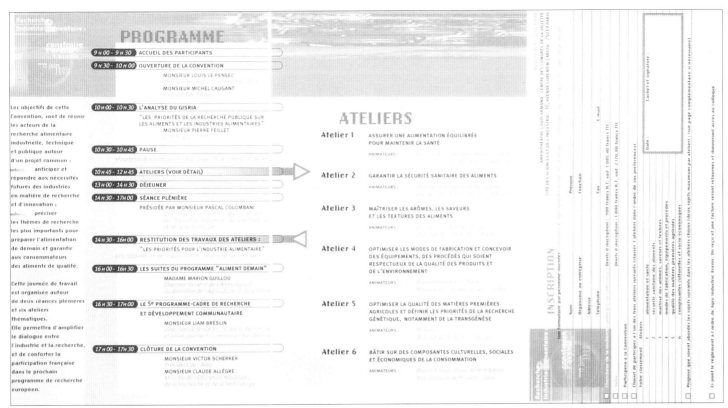

PROGRAMME

| 9 H 00 - 9 H 30 | ACCUEIL DES PARTICIPANTS |
| 9 H 30 - 10 H 00 | OUVERTURE DE LA CONVENTION |

MONSIEUR LOUIS LE PENSEC
MONSIEUR MICHEL CAUGANT

Les objectifs de cette Convention, sont de réunir les acteurs de la recherche alimentaire industrielle, technique et publique autour d'un projet commun :

| 10 H 00 - 10 H 30 | L'ANALYSE DU GISRIA |

"LES PRIORITÉS DE LA RECHERCHE PUBLIQUE SUR LES ALIMENTS ET LES INDUSTRIES ALIMENTAIRES"
MONSIEUR PIERRE FEILLET

| 10 H 30 - 10 H 45 | PAUSE |

anticiper et répondre aux nécessités futures des industries en matière de recherche et d'innovation ;

10 H 45 - 12 H 45	ATELIERS (VOIR DÉTAIL)
13 H 00 - 14 H 30	DÉJEUNER
14 H 00 - 17 H 00	SÉANCE PLÉNIÈRE

PRÉSIDÉE PAR MONSIEUR PASCAL COLOMBANI

préciser les thèmes de recherche les plus importants pour préparer l'alimentation de demain et garantir aux consommateurs des aliments de qualité.

| 14 H 30 - 16 H 00 | RESTITUTION DES TRAVAUX DES ATELIERS : |

"LES PRIORITÉS POUR L'INDUSTRIE ALIMENTAIRE"

| 16 H 00 - 16 H 30 | LES SUITES DU PROGRAMME "ALIMENT DEMAIN" |

MADAME MARION GUILLOU

Cette journée de travail est organisée autour de deux séances plénières et six ateliers thématiques. Elle permettra d'amplifier le dialogue entre l'industrie et la recherche, et de conforter la participation française dans le prochain programme de recherche européen.

| 16 H 30 - 17 H 00 | LE 5ᵉ PROGRAMME-CADRE DE RECHERCHE ET DÉVELOPPEMENT COMMUNAUTAIRE |

MONSIEUR LIAM BRESLIN

| 17 H 00 - 17 H 30 | CLÔTURE DE LA CONVENTION |

MONSIEUR VICTOR SCHERRER
MONSIEUR CLAUDE ALLÈGRE

ATELIERS

Atelier 1 — ASSURER UNE ALIMENTATION ÉQUILIBRÉE POUR MAINTENIR LA SANTÉ
ANIMATEURS :

Atelier 2 — GARANTIR LA SÉCURITÉ SANITAIRE DES ALIMENTS
ANIMATEURS :

Atelier 3 — MAÎTRISER LES ARÔMES, LES SAVEURS ET LES TEXTURES DES ALIMENTS
ANIMATEURS :

Atelier 4 — OPTIMISER LES MODES DE FABRICATION ET CONCEVOIR DES ÉQUIPEMENTS, DES PROCÉDÉS QUI SOIENT RESPECTUEUX DE LA QUALITÉ DES PRODUITS ET DE L'ENVIRONNEMENT
ANIMATEURS :

Atelier 5 — OPTIMISER LA QUALITÉ DES MATIÈRES PREMIÈRES AGRICOLES ET DÉFINIR LES PRIORITÉS DE LA RECHERCHE GÉNÉTIQUE, NOTAMMENT DE LA TRANSGÉNÈSE
ANIMATEURS :

Atelier 6 — BÂTIR SUR DES COMPOSANTES CULTURELLES, SOCIALES ET ÉCONOMIQUES DE LA CONSOMMATION
ANIMATEURS :

Convention
Recherche &
Industrie
alimentaire

ACTIA
ANIA
GISRIA

Mercredi
17 juin
1998

Amphithéâtre Louis Armand
Centre des congrès de La Villette
Cité des Sciences et de l'Industrie
30 av. Corentin-Cariou, 75019 Paris

Construire l'avenir

PASCALE PICHOT & ASSOCIÉS **PP&A**

P P & A

Pascale Pichot & Associés

Dermenghem worked out
several ideas for a corporate-

2e ACT'

Actiades 1997

1er ACT'

Les missions de l'Actia

Dermenghem's stationery for ACTIA features the tree-and-roots logo for this agricultural-science organization, which appears again as a motif in its newsletters.

ART DIRECTOR/CREATIVE DIRECTOR:
Anne-Lise Dermenghem

TRAÇABILITÉ

LE GUIDE PRATIQUE

1998

ÉDITION · ACTIA·ACTA

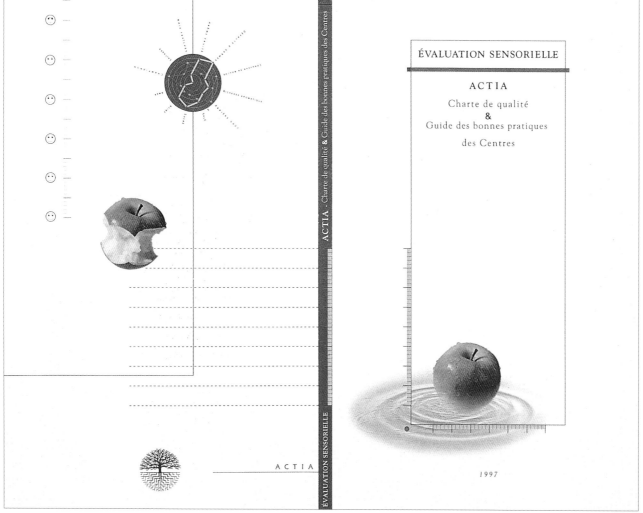

ÉVALUATION SENSORIELLE

ACTIA

Charte de qualité
&
Guide des bonnes pratiques
des Centres

ACTIA · Charte de qualité & Guide des bonnes pratiques des Centres

ÉVALUATION SENSORIELLE

ACTIA

1997

Frequently, Dermenghem's work for ACTIA must lend itself to adaptation for and use in a series, such as these covers for a number of guides that address various agricultural-technical topics.
ART DIRECTOR/CREATIVE DIRECTOR: Anne-Lise Dermenghem

PRINCIPAL: Didier Saco
FOUNDED: 1994
NUMBER OF EMPLOYEES: 5

10, rue des Jeuneurs
75002 Paris
TEL (33) 1-40.26.96.26
FAX (33) 1-40.26.95.26

The Didier Saco Design studio initially proposed, as a representative sampling of its work, the publication of almost barren layouts showing only the familiar logotypes of some of the corporate clients for which it has created brochures, packaging, and other materials over the years. After all, its founder and artistic director Didier Saco pointed out, many of their names have become household words not only in France, but also around the world. Thus, for many readers, the mere mention of their names would immediately evoke vivid recollections of their respective visual identities, which have become well-known through advertising, packaging, and other modes of brand promotion. Saco also noted that many members of Paris's relatively small graphic-design community work or have worked for many of the same clients. In sum, therefore, he acknowledged the local, collective creativity and shared aesthetics that have shaped the design identity of major brands; at the same time, he still recognizes the contributions that different designers make—and, implicitly, the challenges that they face—in tweaking, revising, adding to or even reconceptualizing those established design schemes. Saco, creative director Laurent Dumté, and three other collaborators routinely immerse themselves in brand analysis and marketing research in considering the directions their designs will take. These studious investigations underlie their work's evident style and polish.

DIDIER SACO
DESIGN GRAPHIQUE

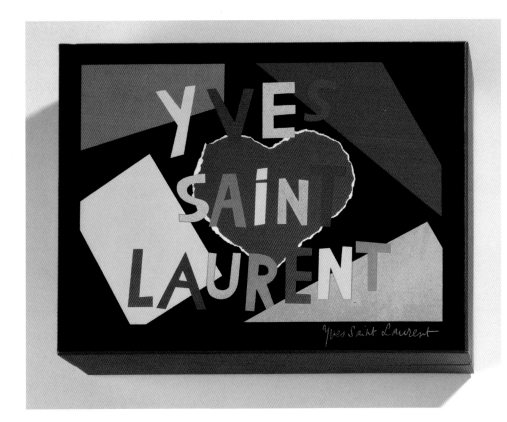

Vibrant color and a cut-paper effect are put to use in the design of this box that holds a selection of bottles of Yves Saint Laurent perfumes for Valentine's Day.

Love
Love
Love
1996

Yves Saint Laurent

For four decades, French fashion designer Yves Saint Laurent has been known for the richness and refinement of his color palettes. This aspect of the artist-designer's sensibility is reflected in this greeting card, which was created for the couture division of his fashion company.

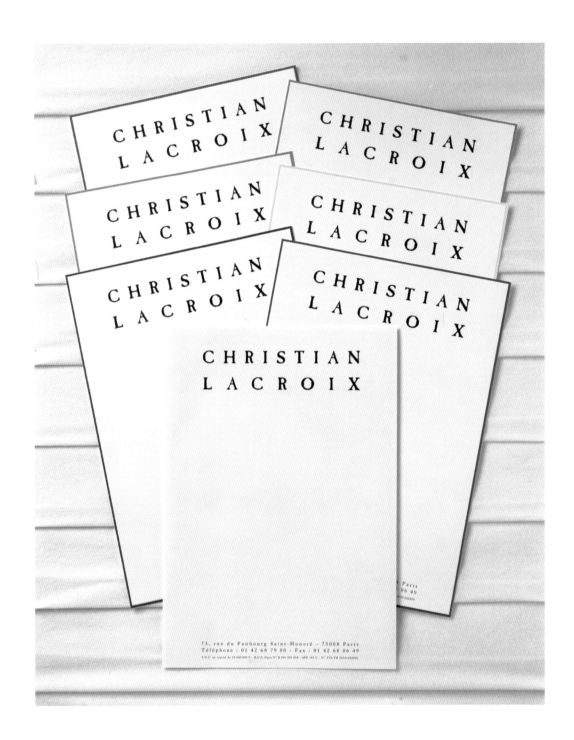

CHRISTIAN LACROIX

« LE GRILLON »

m a r s 1 9 9 7

LACROIX, 10 ANS

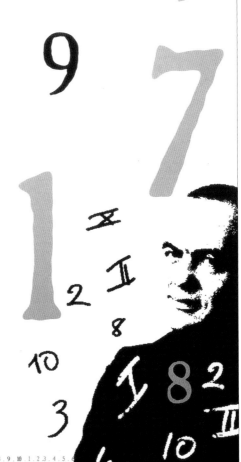

Cette année, la Maison Christian Lacroix a 10 ans. Sans tomber dans la manie si contemporaine de la délectation du passé et du culte des décennies, un anniversaire reste un anniversaire, moins comme une célébration que comme un retour sur soi. Il s'agit peut-être, à l'heure où l'on grandit, de se replonger dans ses racines, de cultiver sa mémoire, de faire un bilan d'un moment passé pour en tirer tous les enseignements possibles.
Tout au long de cette année, *Le Grillon* se propose d'évoquer ce morceau de vie écoulé au travers des différents événements — internes commes externes — qui ont accompagné la Maison. Commençant par le commencement, Christian Lacroix a répondu à nos questions.

Le Grillon — Que représentent ces dix ans ?

Christian Lacroix — Cette période des dix ans est pleine d'enseignements et, par là même, riche en potentiel d'évolution pour la maison. C'est maintenant que nous pouvons commencer à vérifier ou à contredire nos intuitions passées : que nous pouvons commencer à mesurer le pourquoi de nos succès et de nos erreurs. Avec le recul, 1987 nous apparaît aujourd'hui comme un véritable moment de grâce, celui où nous avons eu des intuitions pour des décennies. C'était une époque de prépondérance parisienne, l'apogée du « chef-d'œuvre obligatoire », une époque ou la signature comptait plus que le reste. C'était aussi le moment pour être différent, pour cultiver un écart, imposer une différence. Ce que nous avons fait à ce moment-là, dans l'enthousiasme des débuts, est un capital qui n'en finit pas de nous apporter.
Bien sûr, certaines choses ont mieux vieillies que d'autres, et ce sont souvent les plus folles, les plus « à côté », celles faites le plus souvent dans l'urgence qui ont le mieux résistées ; je pense par exemple aux salons du Faubourg Saint-Honoré, réalisés par Garouste et Bonetti, ou encore à certains univers stylistiques des débuts, comme le télescopage des époques et des folklores.

The French fashion designer Christian Lacroix has been well-known for the flamboyance, opulence, and bold color of his haute couture, characteristics that spilled over, to some degree, into his ready-to-wear clothes. In creating a newsletter and updating a corporate-identity scheme for Lacroix, Didier Saco Design sought, as its director notes, "a straighter, less baroque image, one that was more rigorous and less anecdotal."

INSTITUT FRANÇAIS DE LA MODE

Repères
Mode &
Textile 96

Visages d'un secteur

For the Institut Français de la Mode, a center that disseminates information about and encourages education and training in various areas of the fashion industries, Didier Saco Design created a format for a series of publications on fashion-related themes.

S A C O

The organizing principle of Didier Saco's own logo is simple; it places each letter in the surname of the studio's founder in each quadrant of a square.

In the word *L'Oréal,* the prominent letter *O* is larger, and an otherwise meddlesome apostrophe and accent mark are neatly integrated into the design in this logo for a line of L'Oréal hair-care products.

L'ORÉAL
PROFESSIONNEL
PARIS

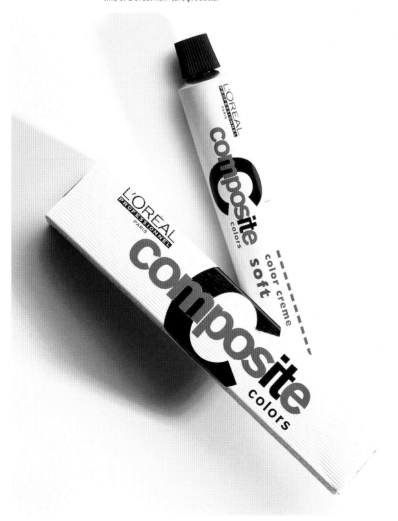

PRINCIPALS: Dusan Ivanovic, François Mussard
FOUNDED: 1996

77, rue de Charonne
75011 Paris
TEL (33) 1-43.48.72.96
FAX (33) 1-40.09.03.79

Dusan Ivanovic is a designer in the great French tradition of the artist-intellectual, but his work, which is always fresh, clever, and intriguing, is never weighed down by heavy theory. Ivanovic was born and grew up in the former Yugoslavia before his family moved to Rouen when he was a boy. He fell in love with photography and went on to study visual communications at the prestigious École Nationale Supérieure des Arts Décoratifs in Paris. A skilled painter, Ivanovic helped mount large art exhibitions before landing his first big design project in the mid-1980s, the development of posters, signage, and installations for the new Cité des Sciences et de l'Industrie museum in Paris. In 1988, with François Fiévé, he launched a private graphic design school. Two years later, with Fiévé and Constance Grison, he founded Tatum Action Graphique, a studio that later evolved into the one that he operates today. Ivanovic is well-known for the posters he has created for Théâtre 13; in them, he says, he "chose to give prominence to typography" and to "show the pixel" in images he manipulated with the computer he was then learning to use. An effective poster, Ivanovic notes, must be quickly understood. But, he adds, "At the same time, a simple image can suggest an open and a deep reading...[and] in fulfilling its information-giving role, it reinforces the image of the organization that commissioned it."

DUSAN IVANOVIC/TATUM

Ivanovic designed this catalog for an exhibition about trees for an agricultural-sciences center in the town of Arras.
ARTDIRECTOR/CREATIVE DIRECTOR/
PHOTOGRAPHY: Dusan Ivanovic

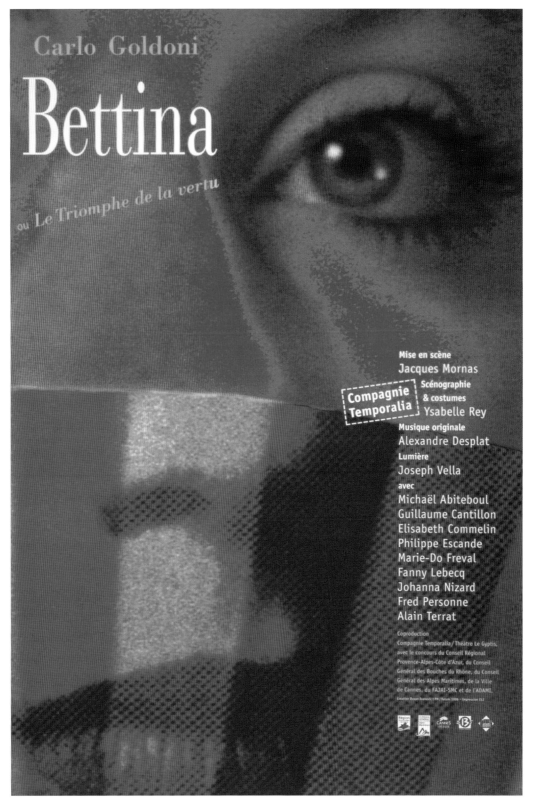

Carlo Goldoni

Bettina

ou Le Triomphe de la vertu

Mise en scène
Jacques Mornas

Scénographie
& costumes
Ysabelle Rey

Compagnie
Temporalia

Musique originale
Alexandre Desplat

Lumière
Joseph Vella

avec
Michaël Abiteboul
Guillaume Cantillon
Elisabeth Commelin
Philippe Escande
Marie-Do Freval
Fanny Lebecq
Johanna Nizard
Fred Personne
Alain Terrat

Coproduction
Compagnie Temporalia / Théâtre Le Gyptis,
avec le concours du Conseil Régional
Provence-Alpes-Côte d'Azur, du Conseil
Général des Bouches du Rhône, du Conseil
Général des Alpes Maritimes, de la Ville
de Cannes, du FAJAI-SMC et de l'ADAMI.

Splitting the composition into
two strong color fields, with an
underlying photo image, gives
this poster for a production by
the Compagnie Temporalia
theater troupe its bold impact.
ARTDIRECTOR/CREATIVE DIRECTOR/
PHOTOGRAPHY: Dusan Ivanovic

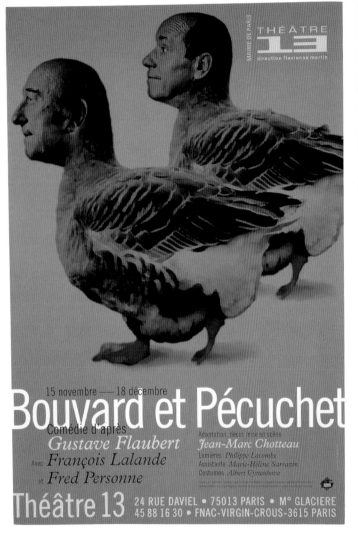

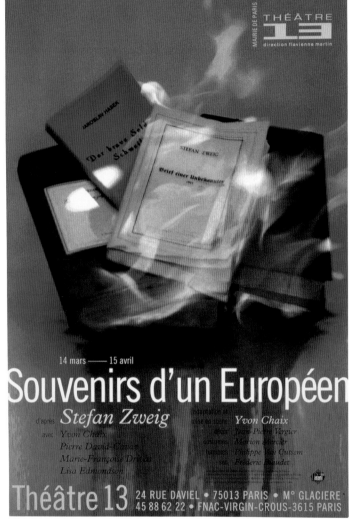

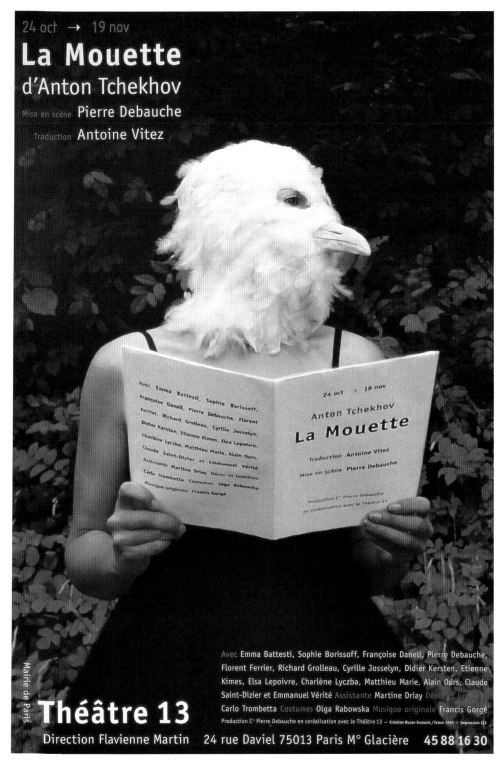

Ivanovic usually does the photography for his posters himself, as in these for Théâtre 13. Sometimes his images can be funny-poetic, and they always make a powerful impression. The effectiveness of a poster's impact, the designer says, "depends on its specifically plastic qualities and its use of strong signifiers that are capable of seizing a viewer's attention."

ART DIRECTOR/CREATIVE DIRECTOR/ PHOTOGRAPHY: Dusan Ivanovic

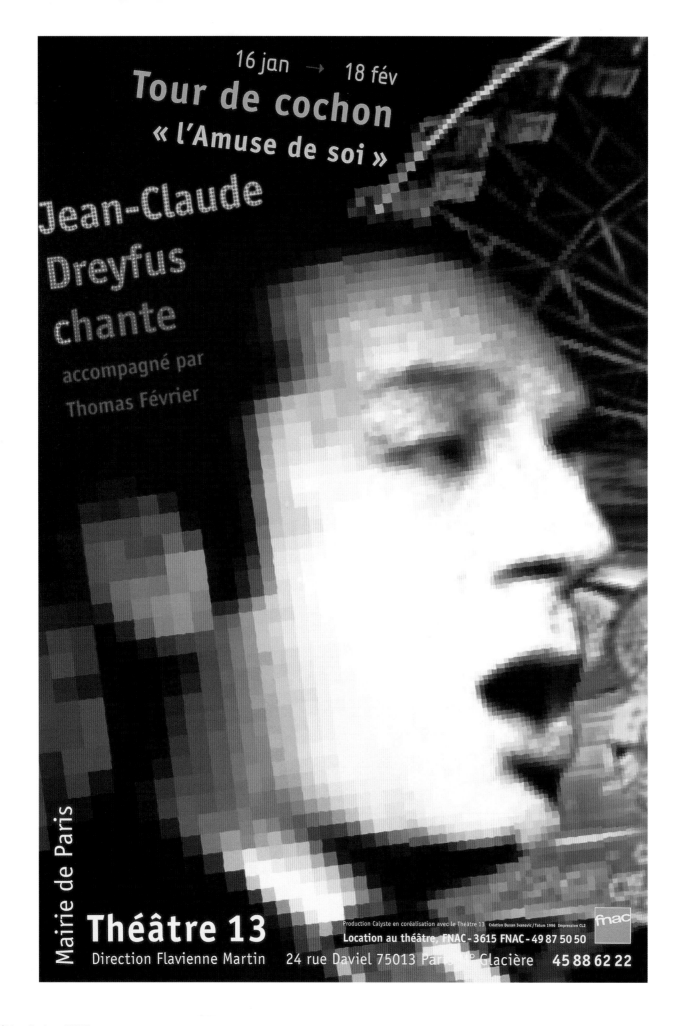

Dusan Ivanovic is well-known for the posters he created for several seasons for Théâtre 13. In many of these designs, he chose to give typography a major role. He also decided to literally show the pixel in a vivid allusion to the powerful computer tool that he was learning to use at the time.

ART DIRECTOR/CREATIVE DIRECTOR/ PHOTOGRAPHER: Dusan Ivanovic

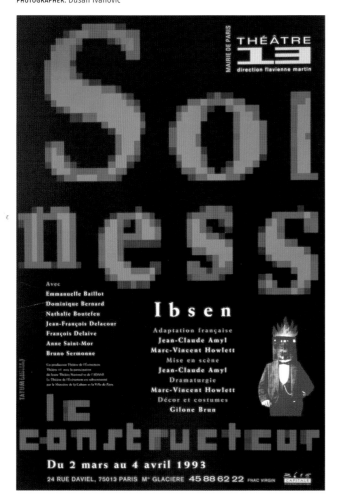

Où
Accès par le 24 rue Daviel (sauf samedi et dimanche)
ou par la dalle piétonne rue de la Glacière (face au n°100)
Métro Glacière – Autobus n°21 (station Glacière-Daviel)

Quand
Les spectacles ont lieu du mardi au samedi à 20 h 30
et le dimanche à 15 h (relâche le lundi)

Comment
Réservation sur simple appel téléphonique au 45 88 62 22
en semaine de 14 h 30 à 19 h 30 ou par FNAC, VIRGIN,
le CROUS et le KIOSQUE

Combien
L'abonnement : deux formules au choix
Formule 4 spectacles : 240 F
La Mouette, Valse n°6 / Les Nuits florentines, Tour de cochon
et Les Chiens de conserve

Formule 6 spectacles : 340 F
La Mouette, Valse n°6 / Les Nuits florentines, Tour de cochon,
Les Chiens de conserve, La Fugitive et Hôtel des Éphémères

N.B. : La Fugitive et Hôtel des Éphémères ne seront présentés
que deux semaines chacun

Avantages de l'abonnement
Vous pouvez choisir vos dates en toute liberté (il vous suffit
de confirmer votre venue quelques jours à l'avance)
Vous êtes invités en cours d'année à diverses manifestations
La personne qui vous accompagne bénéficie du tarif réduit

Tarifs hors abonnement
Plein tarif : 120 F
Tarif réduit : 85 F (moins de 26 ans, cartes vermeil,
demandeurs d'emploi, habitants du 13e arrondissement,
spectateurs privilégiés, collectivités, groupes de 10 personnes)
Groupes scolaires : 60 F

Et pour dîner
Le Bar du Théâtre 13 vous propose dès 18 h
ses assiettes gourmandes

Théâtre 13 mode d'emploi

THÉÂTRE 13

Théâtre 13
direction Flavienne Martin 24 rue Daviel 75013 Paris 45 88 16 30

Saison 1995-1996

Sober, straightforward clarity
is the hallmark of Ivanovic's
16-page booklet announcing
and describing a season of
Théâtre 13's performances.
ART DIRECTOR/CREATIVE DIRECTOR:
Dusan Ivanovic
PHOTOGRAPHY: Dusan Ivanovic,
Philippe Soussan

Les Chiens de conserve
de Roland Dubillard
Mise en scène Catherine Marnas
Distribution en cours

Les Chiens de conserve est un scénario
inédit de film. On y retrouve le comique propre
à l'auteur, un jeu permanent sur les mots,
mais l'originalité de cette œuvre réside
surtout dans son intrigue à suspense.
Suite à une lettre anonyme lui annonçant
le meurtre de sa fille, le vieux Garbeau
se précipite, revolver en main, dans sa Roll-Mops
jaune citron et assassine son gendre...
Il s'agit véritablement d'une intrigue policière
avec une course poursuite digne d'un « thriller ».

12 mars → 14 avril

Le visage de clown
lunaire de Roland Dubillard
enchanta les premiers films
de Jean-Pierre Mocky
(La grande lessive,
Les Compagnons
de la Marguerite...).
Acteur, auteur
(Naïves Hirondelles,
Les Diablogues,
Les nouveaux Diablogues,
Les Crabes...) et metteur
en scène, il est aussi fasciné
par la radio où son émission
Grégoire et Amédée,
qui deviendra plus tard
Les Diablogues, a marqué
toute une génération.

Coproduction
Théâtre La Passerelle – Gap,
C² Paris,
[...]

Les Chiens de conserve

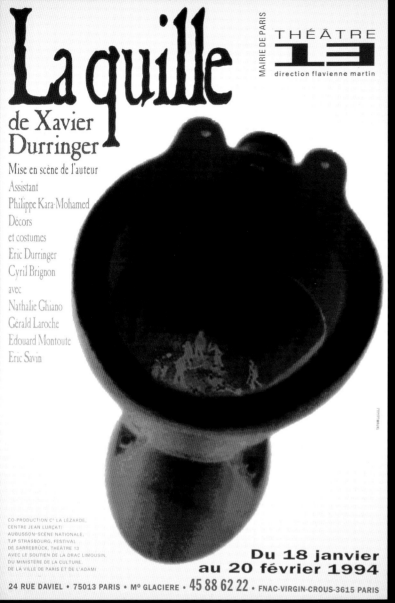

La quille

de Xavier Durringer

Mise en scène de l'auteur

Assistant

Philippe Kara-Mohamed

Décors

et costumes

Eric Durringer

Cyril Brignon

avec

Nathalie Ghiano

Gérald Laroche

Edouard Montoute

Eric Savin

**Du 18 janvier
au 20 février 1994**

24 RUE DAVIEL • 75013 PARIS • Mᵒ GLACIERE • 45 88 62 22 • FNAC-VIRGIN-CROUS-3615 PARIS

MAIRIE DE PARIS

THÉÂTRE 13
direction flavienne martin

Arresting images, a historically flavored display typeface, and a logo that Ivanovic has described as "architectural and geometric" appear in these posters for Théâtre 13.

ART DIRECTOR/CREATIVEDIRECTOR/ PHOTOGRAPHY: Dusan Ivanovic

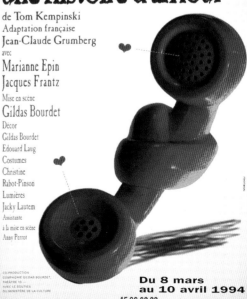

MAIRIE DE PARIS

THÉÂTRE 13
direction flavienne martin

Encore une histoire d'amour

de Tom Kempinski

Adaptation française

Jean-Claude Grumberg

avec

Marianne Epin

Jacques Frantz

Mise en scène

Gildas Bourdet

Décor

Gildas Bourdet

Edouard Laug

Costumes

Christine

Rabot-Pinson

Lumières

Jacky Lautem

Assistante

à la mise en scène

Anny Perrot

**Du 8 mars
au 10 avril 1994**

24 RUE DAVIEL • 75013 PARIS • Mᵒ GLACIERE • 45 88 62 22 • FNAC-VIRGIN-CROUS-3615 PARIS

PRINCIPAL: Malte Martin
FOUNDED: 1988, renamed in 1994

83, rue Léon Frot
75011 Paris
TEL (33) 1-43.79.38.51
FAX (33) 1-44.93.92.40

Several elements that have become general conventions in much contemporary graphic design in Europe and the Americas, and that appear frequently in French designers' work today, find especially graceful, unaffected expression in Malte Martin's portfolio. The computer has made many of these treatments easily executable. Among them: varied type weights, often within the same word or headline phrase; dramatically wide kerning; and curving, swirling, or wrapped-around lines of type. In individual pieces and especially in thoughtfully conceived series of related materials (books, brochures, postcards), often united by strong logos and identity-scheme devices, Martin has repeatedly demonstrated just how flexible and accommodating, yet how visually cohesive and consistent, his design systems can be. An example is his set of posters, brochures, and newsletters for the city theater in Aubervilliers. He has also designed *Traverses,* the arts journal published by the Pompidou Center in Paris, as well as posters for some of this popular art-and-design museum's presentations. The results of design assignments for such institutions, which are funded by the national Ministry of Culture, are highly visible in France. Moreover, in routinely commissioning and distributing posters, brochures, and publications in series, French government agencies play an important role in the cultivation and dissemination of design standards.

MALTE MARTIN
ATELIER GRAPHIQUE

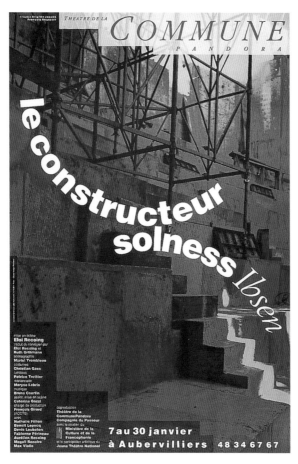

A comprehensive identity scheme for the city theater in Aubervilliers is cohesive and consistently controlled, which reinforces the recognition factor that it seeks to create. At the same time, it is flexible enough to accommodate a range of formats and subject matter in posters, brochures, and postcards for films, performances, and events.

THEATRE DE LA

COMMUNE
P A N D O R A

master class

Staline

Chostakovitch

Jdanov

Prokofiev

de David
Pownall
mise en scène
Michel Vuillermoz
traduction et adaptation
Guy Zilberstein
Michel Vuillermoz
assistant mise en scène
Jean-Pierre Richard
décors et costumes
Bernard Legoux
maquillages
Pascale Fau
éclairages
Patrice Trottier
création musicale
et interprétation
Yvan Cassar
avec
Jean-Pol Dubois
Philippe Faure
Patrick Ligardes
Michel Vuillermoz

co-production
Théâtre de la
Commune Pandora,
La Rose des Vents
Scène Nationale de
Villeneuve d'Ascq,
Centre National Dramatique
et Chorégraphique
Le Quartz de Brest,
La Double Hélice
Ministère de la Culture
ADAMI

**26 jan • 21 fév
à Aubervilliers 48 34 67 67**

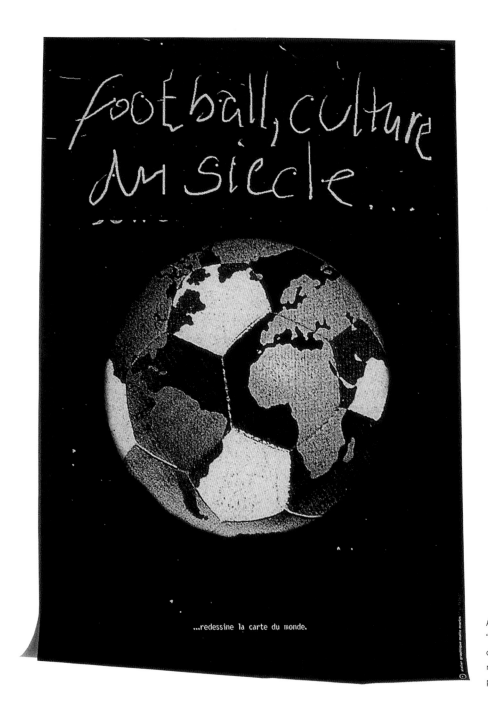

A poster with the headline "Football, the culture of the century is redrawing the map of the world" packs a powerful visual pun.

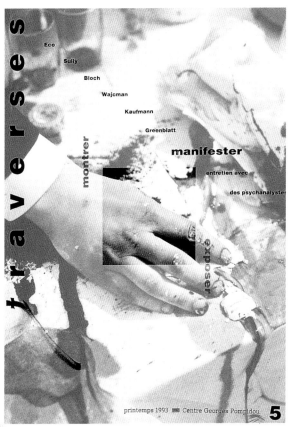

Martin's designs for *Traverses*, an arts journal published by the Pompidou Center, gracefully speak a kind of cultural-institution, corporate vernacular that is not unfamiliar in France.

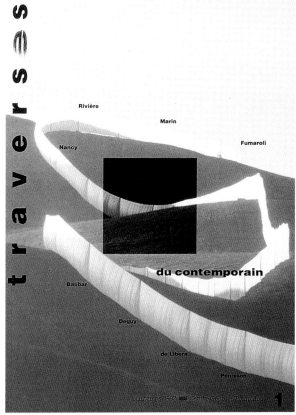

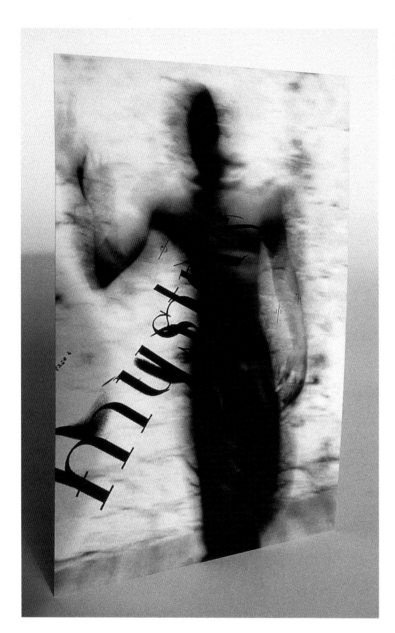

Overlapping type, a fuzzy photo image of a human form and a text block set askew evoke a suitably off-kilter mood for this announcement for a dance performance entitled *Mystery*.

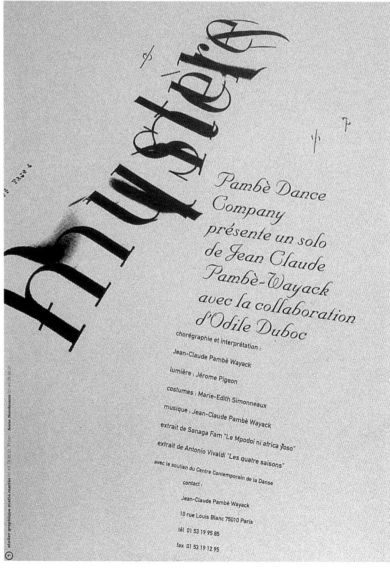

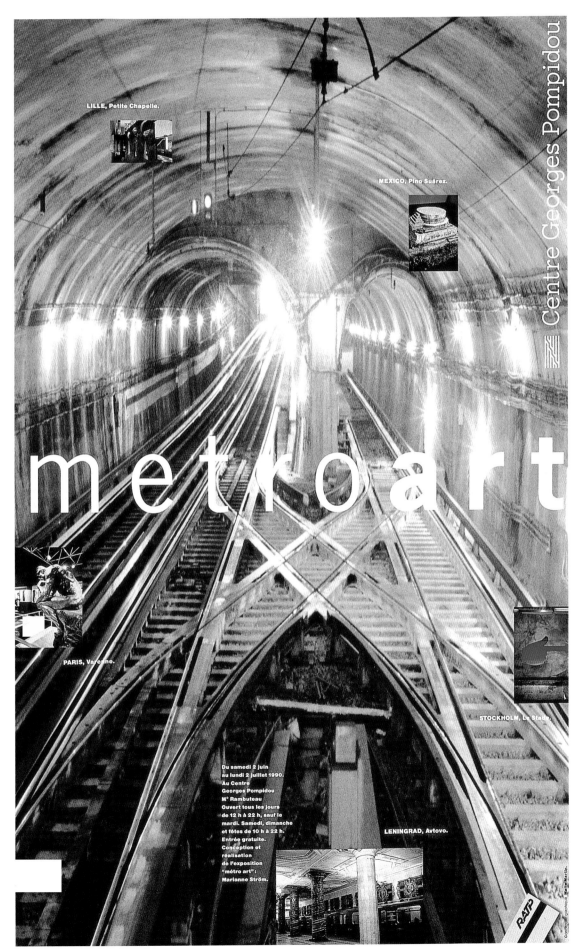

LILLE, Petite Chapelle.

MEXICO, Pino Suárez.

Centre Georges Pompidou

metroart

PARIS, Varenne.

STOCKHOLM, Le Stade.

Du samedi 2 juin
au lundi 2 juillet 1990.
Au Centre
Georges Pompidou
M° Rambuteau
Ouvert tous les jours
de 12 h à 22 h, sauf le
mardi. Samedi, dimanche
et fêtes de 10 h à 22 h.
Entrée gratuite.
Conception et
réalisation
de l'exposition
"métro art" :
Marianne Ström.

LENINGRAD, Avtovo.

RATP

Varied type weights within the main headline and an underlying, structural grid indirectly visible in the lower text block and the inset photographic images appear in this poster. It advertises an exhibition at the Pompidou Center about art on view in subway stations.

Martin sets a simultaneously
playful and stately tone in
this large-format magazine
published by an association of
puppet theaters. Inside, he uses
his signature hairlines both
decoratively and to organize
graphic elements within layouts.
Irregularly slanted text columns
are one of their most striking
features; they read easily and
amount to more than just a
visual gimmick.

Martin uses a favorite,
casual-elegant typeface, an
image of birds in flight, and
abstract artwork in a brochure
for a dance company.

PRINCIPALS: Sophie Millot,
Philippe Millot
FOUNDED: 1993

46, rue Miguel-Hidalgo
75019 Paris
TEL (33) 1-40.18.37.60
FAX (33) 1-40.18.37.63

For Sophie and Philippe Millot, the labels "typography" and "graphic design" do not exactly describe what it is that they create for such clients as Radio France or the Department of Cultural Affairs of the City of Paris. Compared to other designers' work, the Millots' posters, book covers, and promotional materials of different kinds feature especially well-integrated elements of typography, illustration, or color. In them, they appear to compose their layouts and draw with these graphic components at the same time. In their work, visual puns abound, as do bursts of expressive typography, as in the Millots' poster for writers from France's overseas territories. Here, the words *d'outre mer,* referring to those off-shore places, appear in a cluster of letters of varied weights and sizes against a blue ground, like a group of islands afloat in a vast sea. Philippe Millot,

who has taught at the Amiens School of Design, says: "I try to transpose my ideas into another language…intelligently, accurately, sensitively, at every level of the production of the text." In the broadest sense of design as a visual language, he adds, this is the practice of orthography (spelling) that gives the Millots' ideas visible form.

SOPHIE & PHILIPPE MILLOT

This poster for an exhibition about writers from France's overseas territories packs a visual pun. The words *d'outre mer,* referring to those offshore places, appear in a cluster of letters set against a blue ground, like islands afloat in a vast sea.

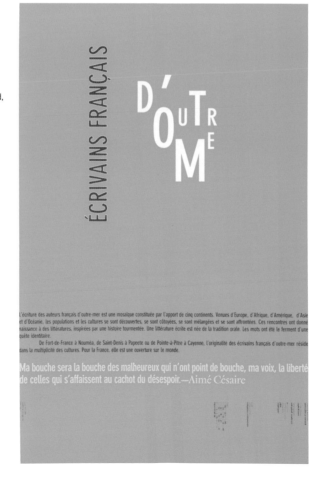

LOUIS ARMSTRONG

LES CLASSIQUES DE LOUIS ARMSTRONG 1923-1945

COLLECTION FRANCE MUSIQUE

The Millots bring their classic, clean, type-driven touch to the design of a CD of Louis Armstrong's music.

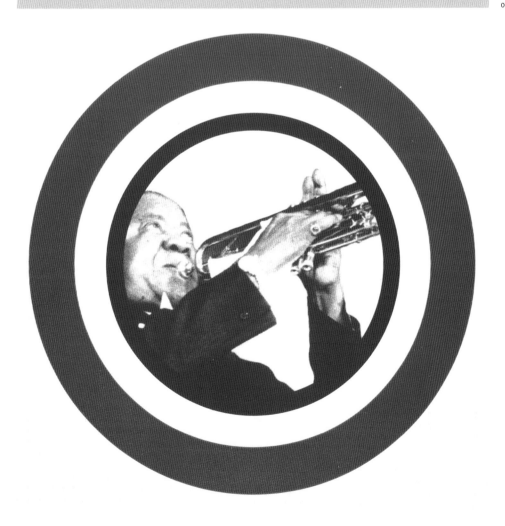

The elaborated headlines in these posters for exhibitions of photography of historic Parisian sights exude a sense of craftsmanship with a dramatic edge.

	La Semaine		52
Radio France	France Inter	France Info	30 avr. 06 mai. 94
	France Culture	Radios Locales	
	Radio Bleue	France Musique	
	Fip	Fa-Hector	

	La Semaine	Radio France	55
	France Inter	France Info	21 mai. 27 mai. 94
	France Culture	Radios Locales	
	Radio Bleue	France Musique	
	Fip	Fa-Hector	

	La Semaine		51
Radio France	France Inter	France Info	23 avr. 29 avr. 94
	France Culture	Radios Locales	
	Radio Bleue	France Musique	
	Fip	Fa-Hector	

Within a stable, organizing-grid format, the Millots have brought considerable variation and expression to their covers for the weekly bulletin of Radio France, one of their studio's longtime clients.

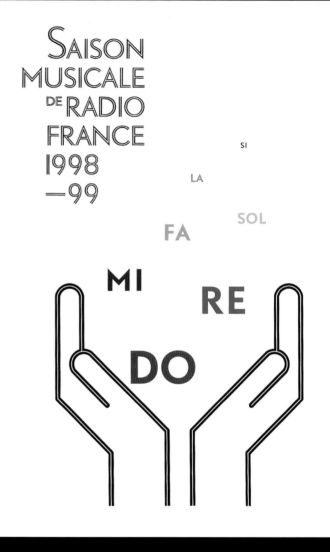

The Millots often draw with colorful graphic and typographic elements even as they compose a design, as they do in this series of posters for a series of concerts sponsored by Radio France.

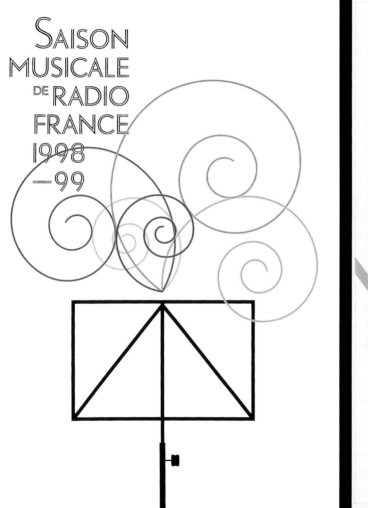

SAISON
MUSICALE
DE RADIO
FRANCE
1998
—99

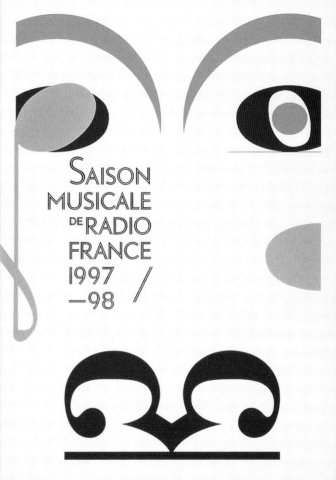

SAISON
MUSICALE
DE RADIO
FRANCE
1997 /
—98

ART CONT EMP ORA IN-

PARIS musées

LES MUSÉES DE LA VILLE DE PARIS

This booklet lists exhibition catalogs available from various museums in Paris. The splash of color on the cover enlivens an otherwise simple, low-budget production.

Le Voyage des dieux

Le Chœur de Radio France invite des musiciens traditionnels:
un itinéraire au cœur des rituels afro-cubain, géorgien, bouddhique & européen.
Samedi 3 décembre 1997, 18 h. Musée des arts d'Afrique & d'Océanie

These small-format, lightweight-cardboard press-kit folders hold promotional materials for concerts and events sponsored by Radio France.

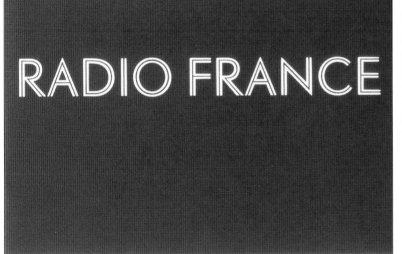

RADIO FRANCE

Direction de la musique

Direction de la musique
Service des relations publiques
Maison de Radio France 116, avenue du Président Kennedy 75220 Paris cedex 16
T: 01 42 30 37 87 F: 01 42 30 38 69

PRINCIPALS: Valérie Debure,
Isabelle Jégo, Alex Jordan, Ronit
Meirovitz, Olaf Mühlmann
FOUNDED: 1990

28, rue Planchat
75020 Paris
TEL (33) 1-40.09.61.50
FAX (33) 1-40.09.61.55

Just as fine artists draw inspiration from an infinite variety of sources, so, too, do graphic designers. They often find themselves inspired, motivated, or informed by more than just aesthetic concerns and matters of style, or primarily by the need to make posters, brochures, or materials that serve essentially commercial purposes. Founded in 1990, the Nous Travaillons Ensemble studio (the name means "we work together") has always expressed a concern for political and social issues affecting people's real lives, not the fantasy lives portrayed in staged scenes with paid models that are the stock in trade of most advertising. Thus, its members—Valérie Debure, Isabelle Jégo, Alex Jordan, Ronit Meirovitz, and Olaf Mühlmann—have specialized in creating exhibition installations, media campaigns, and identity systems for towns and cities, for humanitarian and non-profit organizations, and

for cultural centers. In their designs, hand-drawn or painted, often brushy letterforms or illustrations, with the warm touch of the human hand that they imply, combine with crisp, monochromatic photography and contemporary typefaces. Together, these elements generate an attractive energy. Visual puns can be remarkably effective, too, as in the studio's award-winning poster commemorating the World War II battle at Dieppe. Without taking a moralizing stance, Nous Travaillons Ensemble's work demonstrates the thought-provoking power of socially conscious graphic design.

NOUS TRAVAILLONS
ENSEMBLE

Primary colors and hand-lettering are typical of much of Nous Travaillons Ensemble's work, as in this postage stamp commemorating the fiftieth anniversary of France's national-assistance program.

This poster's stark, cool, red-on-white design hits a viewer like a visual slap in the face. A look at the handwritten words and poetry quotation at the bottom of the composition reveals that the bold red color symbolizes the soldiers' blood that was splattered in a famous World War II battle. This work won France's top prize in 1993 for the cultural poster.

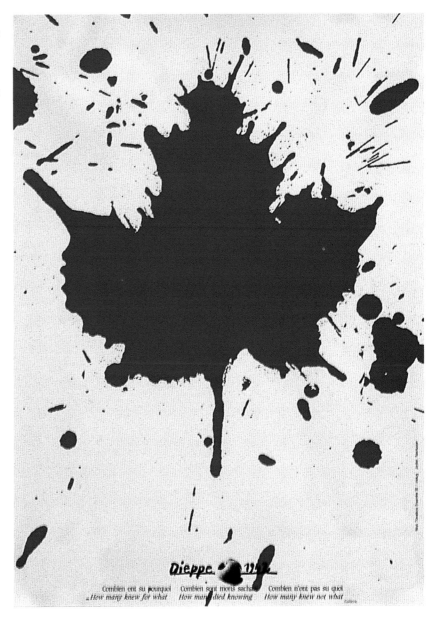

Dieppe 1942

Combien ont su pourquoi Combien sont morts sachant Combien n'ont pas su quoi
How many knew for what How many died knowing How many knew not what

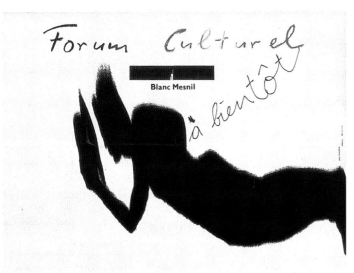

Forum Culturel
Blanc Mesnil
à bientôt

A stop-and-look impact characterizes much of Nous Travaillons Ensemble's work, as in this billboard advertising a cultural center in Blanc Mesnil. The headline: See you soon at the Forum Culturel.

An emblem from nature is set against an urban backdrop in this poster announcing the opening to the public of the warehouses of a cultural center that promotes the art of the book and of the poster.

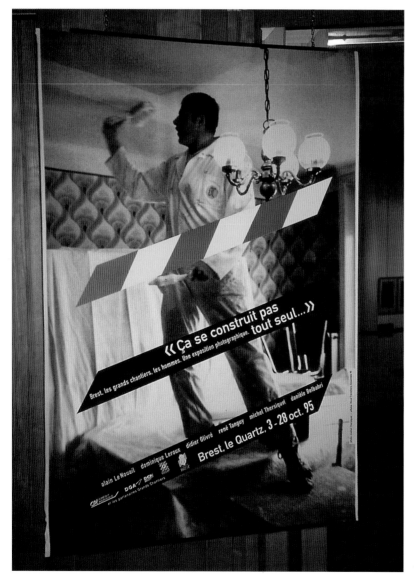

A poster for an exhibition of photos of workers in the construction industries uses a motif picked up from the striped safety barriers that are normally found at building sites.

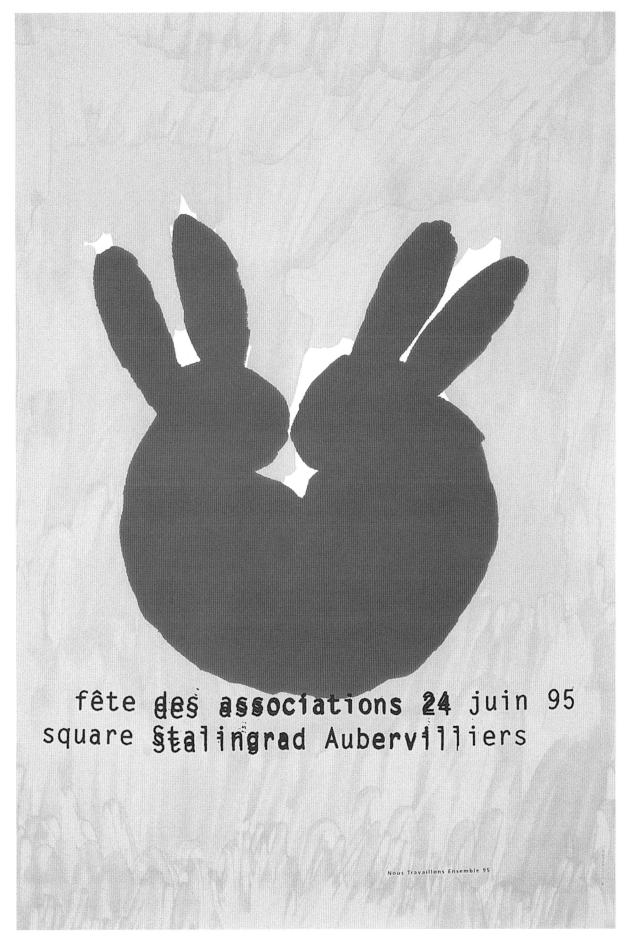

fête des associations 24 juin 95
square Stalingrad Aubervilliers

Nous Travaillons Ensemble 95

The simplicity of many Nous Travaillons Ensemble designs belies their power. In this poster for a gathering of local associations in the town of Aubervilliers, two bright colors and a silhouetted pair of rabbits convey the sense of community and festivity that the event will bring.

This poster announcing the inauguration of the refurbished plaza in front of Aubervilliers' city hall literally draws a curtain over a picture of the open-air space that will be reopened to the public on the date indicated.

The fingerprint, normally a soulless symbol of the helpless individual unknown to a discompassionate government bureaucracy, is transformed into a heart, an icon of community and compassion, in this poster for a festival celebrating France's national-assistance program.

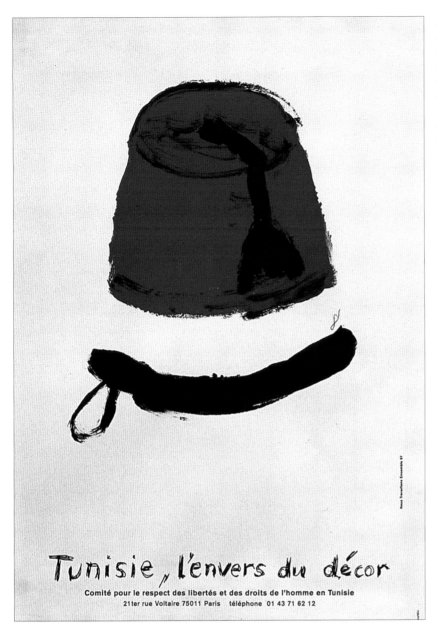

A spare, hand-drawn poster design decrying human-rights abuses in Tunisia contrasts an image of a fez, a specific cultural symbol, with that of a policeman's nightstick, a potentially frightening symbol of authority in any language or culture.

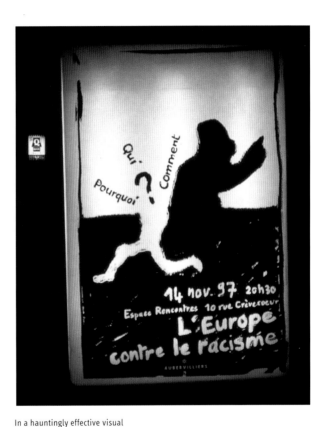

In a hauntingly effective visual pun, one human form, whose head and arms are made up of the words *why, who, how?* emerges out of the negative space of another more menacing body in this poster announcing a meeting, in the town of Aubervilliers, of the group called Europe Against Racism.

This prize-winning poster's design conveys an overtly political or subtly overt political message, depending on one's point of view. With only a dashed line and two silhouetted hands, it urges the nations of the world's industrialized and developed northern regions to reach out and aid those of its often poorer, still-developing southern regions.

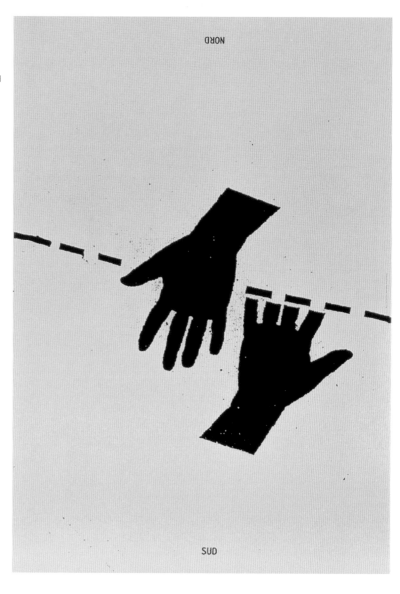

A hand-drawn illustration and hand-lettered type animate this sticker for an anti-littering campaign in the southern city of Nîmes, whose local emblem features an alligator.

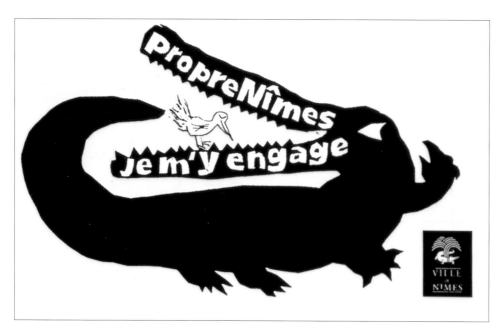

A congenial tone is notable in Nous Travaillons Ensemble's work, one that the graphic elements they employ help reinforce, as in this small, spiral-bound address-and-information book for teenagers. Published by the town of Aubervilliers' public-health agency, it uses bright color and illustrations to grab young readers' attention.

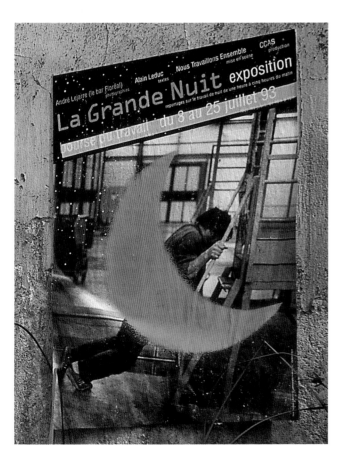

An eye-catching half-moon symbol dominates this poster for an exhibition of photos of people who work at night jobs.

PRINCIPALS: Muriel Paris,
Alex Singer
FOUNDED: 1996

20, rue Dautancourt
75017 Paris
TEL (33) 1-46.27.35.61
FAX (33) 1-46.27.35.61

Like those of their counterparts in other media centers, the portfolios of many Paris-based designers display a diversity of techniques and applications; Muriel Paris and Alex Singer's work, for example, includes corporate-identity schemes, posters, cards, booklets, and other visual-communications forms. In their designs, big ideas sometimes find expression in small-scale forms, as in a series of thematic-conceptual postcards that Paris and Singer created to promote their studio; in composition and impact, they resemble miniature posters. In other works, like Paris and Singer's program booklets for film series sponsored by the *département* (one of France's geographic-administrative units) of Val-de-Marne, unusual headline typefaces help give information-packed printed pieces their distinctive character. At its best, Paris and Singer's work uses familiar, contemporary stylistic touches, like varied typefaces on one page or within one piece, not only for their looks, but clearly in the service of clarity and ease of use.

MURIEL PARIS ET
ALEX SINGER

Vitrolles 1997 : le fascisme est passé

These thematic-conceptual postcards promote Paris and Singer's studio; in composition and impact, they resemble miniature posters.
ART DIRECTORS/CREATIVE DIRECTORS/DESIGNERS: Muriel Paris, Alex Singer

France

sarl

société anonyme à responsabilité limitée

bientôt l'an 2000

muriel paris

AFFECTION CHRONIQUE

ALEX SINGER & MURIEL PARIS

Muriel Paris et Alex Singer

Bright yellow and purple on white stock, and a thick jumble of typefaces that are still remarkably crisp and readable, enliven this brochure announcing an international conference on typography.
ART DIRECTOR/CREATIVE DIRECTOR/ DESIGNER: Muriel Paris

This black-and-white, self-promotional poster for the studio, entitled *Love Letter*, allows the viewer to check off boxes for phrases and pictures that, together, express feelings for the object of his or her affection.

ART DIRECTORS/CREATIVE DIRECTORS/DESIGNERS: Muriel Paris, Vanina Gallo

Elisabeth Allaire
préfet de la Haute-Marne
Jean Claude Etienne
président du conseil régional
Bruno Sido
président du conseil général
Jean Claude Daniel
député-maire de Chaumont
Pascal Grisoni
président des rencontres internationales des arts graphiques
Alain Weill
délégué général du festival
Patrick Giraudo
directeur du graphisme, les silos

**vous prient de bien vouloir honorer de votre présence
l'inauguration des 9e rencontres internationales des
arts graphiques de chaumont co-produites avec la région
Champagne Ardenne et l'office régional culturel**

samedi 6 juin 1998, à partir de 9h30, aux silos,
maison du livre et de l'affiche, 7-9 avenue du Maréchal Foch

This small program for the Ninth
Poster Festival of Chaumont,
with its coordinated invitation
card, unfolds to reveal a map of
venues and, at each end of the
folded-out, four-panel piece,
a booklet. One contains a listing
of the festival's events, the
other offers information about
participating poster artists.
**ART DIRECTORS/CREATIVE
DIRECTORS/DESIGNERS:** Muriel Paris,
Alex Singer

1. Entrepôts des Subsistances
2. Grand garage
3. Chapelle des Jésuites
4. Ancien théâtre
5. Salon des expositions
6. Les silos
7. Ancienne Bibliothèque
8. Cinéma Éden
9. Marché couvert
10. Hôtel de Ville
11. Office du Tourisme
12. Cinéma Vox

PROGRAMME EXPOSITIONS

ARLETTE SINGER

ARCHITECTE AGRÉÉ · ARCHITECTE D'INTÉRIEUR

19 cours Gambetta 83570 Cotignac
tél : (33) 04 94 04 62 71
fax : (33) 04 94 04 64 91

Dotted-line and yellow-dot
patterns give this stationery

L'oeil vers... **le japon**

16e journées cinématographiques du Val-de-Marne
contre le racisme, pour l'amitié entre les peuples
du 25 novembre au 9 décembre 1997
informations : 01 45 13 17 00 avec l'aide de la Direction régionale des affaires
culturelles d'Île-de-France et du Fonds d'Action
sociale – Délégation Île-de-France

L'oeil vers...
les jeunes au cinéma

15e journées cinématographiques
contre le racisme pour l'amitié
entre les peuples
du 26/11 au 10/12 1996 • informations : 01 45 13 17 00

	L'Âge des possibles	À toute vitesse	Beautiful thing	Chungking express	Dans la Mêlée	Eldorado	État des lieux	Gas food and lodging	Halfaouine	Kids	Manuel/le fils emprunté	Mélisse	Muriel	Naked	Nous, les enfants du xxe siècle	
mercredi 27 novembre	14h15 Arcueil Jean Vilar	18h15 Arcueil Jean Vilar	18h Créteil la Lucarne		21h Arcueil Jean Vilar	21h Créteil la Lucarne		16h Arcueil Jean Vilar						20h30 Orly Aragon	14h30 Orly Aragon	14h30 Créteil la Lucarne
jeudi 28 novembre	21h Créteil la Lucarne	21h15 Arcueil Jean Vilar					14h Arcueil Jean Vilar	18h15 Arcueil Jean Vilar	9h30 & 14h30 Créteil Bordières						18h30 Créteil la Lucarne	
vendredi 29 novembre	18h15 Arcueil Jean Vilar	18h Bonneuil Gérard Philipe					14h Orly MJC	20h30 Bonneuil Gérard Philipe		18h30 Créteil la Lucarne	21h Créteil la Lucarne	21h15 Arcueil Jean Vilar				
samedi 30 novembre	18h Villejuif Romain Rolland	17h Créteil la Lucarne	21h Villejuif Romain Rolland	18h15 Arcueil Jean Vilar	14h15 Arcueil Jean Vilar	21h Créteil la Lucarne	20h30 Bonneuil Gérard Philipe	23h Villejuif Romain Rolland	17h Créteil MPT La Haye aux Moines	16h15 Arcueil Jean Vilar	15h Créteil la Lucarne	21h Fontenay le Kosmos	16h Bonneuil Gérard Philipe	21h Bonneuil Gérard Philipe	19h30 Fontenay le Kosmos · 21h15 Arcueil Jean Vilar	
dimanche 1er décembre	16h Orly Aragon		16h45 Arcueil Jean Vilar			14h30 Bonneuil Gérard Philipe		15h Créteil la Lucarne	15h Créteil MPT La Haye aux Moines		17h Créteil la Lucarne	16h30 Bonneuil Gérard Philipe	14h30 Créteil la Lucarne		17h30 Orly Aragon · le Kosmos	
lundi 2 décembre	18h Orly Aragon	14h30 Créteil la Lucarne										18h30 Créteil la Lucarne			21h Créteil la Lucarne	
mardi 3 décembre	20h30 Orly Aragon	21h Créteil la Lucarne	21h15 Arcueil Jean Vilar					18h15 Arcueil Jean Vilar	9h15 & 14h Limeil Brévannes Anatole France	14h Créteil la Lucarne	14h Orly MJC		18h Orly Aragon	20h30 Orly Aragon		
mercredi 4 décembre	18h & 20h30 Champigny Gérard Philipe	18h Orly Aragon		18h30 Créteil la Lucarne	20h30 Fontenay le Kosmos		21h Créteil la Lucarne	20h30 Orly Aragon	14h30 Bonneuil Gérard Philipe		10h Orly MJC	18h30 Créteil la Lucarne				
jeudi 5 décembre		21h Créteil la Lucarne							18h30 Créteil la Lucarne							
vendredi 6 décembre		18h & 20h30 Champigny Gérard Philipe	21h Fontenay le Kosmos	21h Créteil la Lucarne			18h Bonneuil Gérard Philipe	18h30 Créteil la Lucarne				18h				
samedi 7 décembre		18h & 20h30 Champigny Gérard Philipe					14h30 Créteil la Lucarne	17h Créteil la Lucarne			21h Créteil la Lucarne					
dimanche 8 décembre	15h Créteil la Lucarne	14h Orly Aragon	14h30 Créteil la Lucarne	16h30 Créteil la Lucarne			18h Orly Aragon	15h Champigny Gérard Philipe	17h30 Fontenay le Kosmos							
lundi 9 décembre	18h Orly Aragon		21h Créteil la Lucarne			18h30 Créteil la Lucarne	20h30 Orly Aragon	14h30 Créteil la Lucarne								
mardi 10 décembre	21h Créteil la Lucarne	20h30 Orly Aragon	18h Bonneuil Gérard Philipe		18h30 & 21h Vitry/ Seine Jean Vilar	20h30 Fontenay le Kosmos	18h30 Créteil la Lucarne									

Unusual headline typefaces help give these program booklets for two different film series their distinctive character. Inside, film-projection schedules are summarized in simple, monochromatic charts bursting with rhythm and visual energy.
ART DIRECTOR/CREATIVE DIRECTOR/DESIGNER, *L'oeil vers le Japon:* Muriel Paris; *L'oeil vers les jeunes au cinéma* created in collaboration with Alex Singer

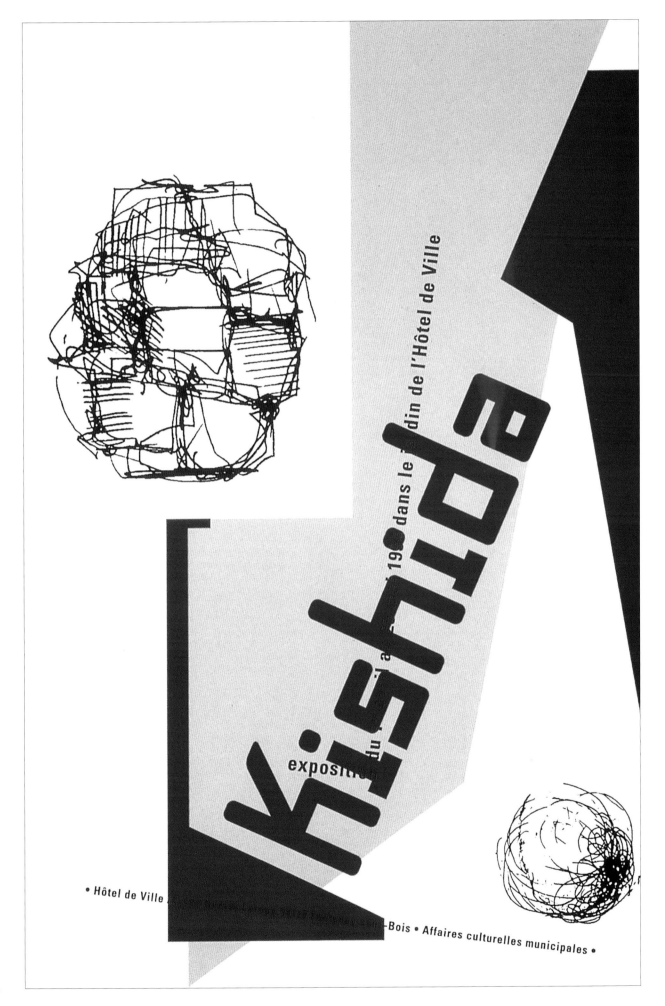

Emphatic splashes of scarlet red strengthen this poster for a sculptor's exhibition in the gardens of the Hôtel de Ville, the French capital's city hall.
ART DIRECTOR/CREATIVE DIRECTOR/DESIGNER: Muriel Paris

PRINCIPAL: Placid

80, rue d'Avron
75020 Paris
TEL (33) 1-40.24.02.56
FAX (33) 1-40.24.29.73

There is a rollicking, careering energy visible in much of the work of the painter, sculptor, graphic artist and designer who calls himself Placid, an unbridled spirit that splashes words, images and colors across layouts and that seems to have as much fun just seeing how certain elements mix as it does in using them to convey particular messages. The notion that the style of a work of graphic design to some degree actually constitutes its content is very much in evidence in Placid's exuberant art direction and design for *Maintenant,* a large-format French magazine about current affairs. So, too, does his work for *Omnibus,* a visual-arts newspaper; for compact-disc packaging; and for book publishers, strongly demonstrate how substantially graphic design gives form to and helps communicate the functions and purposes of the materials to which it is applied. Placid dips into a deep well of pop stylings to inspire his designs, from mixed-up display typefaces and psychedelic patterns to collage-like page compositions that dispense with strict organizing grids. The result is a body of work that is in constant motion, not tied down by any set of rules and continually reinventing itself.

PLACID

The designer's interest in pop culture is reflected in some of the projects he has worked on, like this book about the drug culture and the dance-music scene.

La fabrication du MDMA

E
16
Dance
et contre-culture

Les fêtes gratuites

Les soirées acid house ont fait d'énormes progrès grâce à l'apport des sonos mobiles utilisés pour les concerts gratuits organisés un peu partout en Grande-Bretagne depuis les années 60. Dans ce mariage entre *ravers* et *travellers*, on peut considérer l'été 92 comme la période de la lune de miel. Ces fêtes musicales devaient culminer à la fin du mois de mai par un vaste rassemblement à Castelmorton. Selon les estimations, le nombre des participants oscillait entre 25 000 et 40 000 et, pour la plupart d'entre eux, ce festival était le clou de la saison. Pourtant, les médias ont présenté ce joyeux rassemblement comme une invasion de loubards, et les protestations outrées des honnêtes gens ont préparé le terrain pour une loi répressive, le CJA (*Criminal Justice Act*).

Ce durcissement de la législation, destiné à supprimer les fêtes « sauvages », a eu plusieurs résultats. Le premier, c'est que la nouvelle loi a obligé les jeunes à réintégrer les clubs et autres lieux autorisés. Le gouvernement justifie cette action par le souci de protéger les citoyens, qui sont ainsi supposés ne pouvoir danser que dans des endroits conformes aux normes de sécurité. Dans les faits, les accidents

mortels surviennent précisément dans ces clubs autorisés.

« Il y a eu un mort, ici, dans le Bedfordshire, dit Glenn Jenkins, du collectif *Exodus*. Pas pendant l'une de nos fêtes sans danger (nous en avons organisé 72), mais dans un club. C'est l'une de ces boîtes qui peut contenir 500 personnes, mais on les laisse s'entasser à 1000. Un mec s'est évanoui, et on l'a sorti. Ses copains l'ont emmené à l'hôpital dans leur voiture. Il est mort. Il avait bel et bien pris deux doses d'amphes, mais pas d'ecstasy. Ils disent que l'E tue pendant les raves, ils appellent ça la "danse macabre". Moi je dis que si l'ecstasy était mortelle, il y aurait des millions de gens à sortir les pieds devant. C'est la chaleur et le manque de précautions qui tuent, ce n'est pas la faute de la drogue. On a bien vu arriver le danger. Je me suis déjà trouvé coincé sur une piste, sans pouvoir faire un geste, et malgré ça, je suais comme un bœuf. Pas la peine d'avoir été à l'université pour savoir que c'est terriblement dangereux. »

Le second résultat du CJA a été de pousser à l'exil un certain nombre de groupes musicaux. À la suite du festival de Castelmorton, dix membres de *Spiral Tribe* sont passés en jugement, en 1994, pour atteinte à l'ordre public. Ils ont été relaxés faute de preuves. Un homme de loi de ma connaissance m'a avoué en confidence qu'en raison même de leur notoriété, et du retentissement possible du procès dans la presse (un procès qui a coûté la bagatelle de 4 millions de livres sterling), ils avaient servi de boucs émissaires. *Spiral Tribe* et beaucoup d'autres groupes, à l'étranger, trouvent un accueil beaucoup plus favorable auprès des autorités. Si bien qu'ils ont émigré en masse, avec leur matériel,

vers des contrées plus hospitalières, de l'État de Goa (sur la côte occidentale de l'Inde) à la baie de San Francisco.

La troisième conséquence de la sévérité de la loi s'est fait plus nettement sentir au moment où le CJA a été voté. Certains ont été tellement choqués par les dispositions draconiennes qui visaient à interdire les fêtes qu'ils n'ont eu qu'une envie, organiser des soirées encore plus énormes et plus réussies. L'Advance Party a appelé immédiatement à manifester contre les nouvelles lois et s'est occupé de resserrer ses liens avec d'autres groupements, ce qui n'a pas manqué de politiser le débat. Gail, avec le collectif Justice ?, organise des fêtes clandestines à Brighton. Il explique comment la loi a modifié leur tactique :

« À cause du CJA, justement, nous étions bien décidés à organiser des fêtes encore plus spectaculaires, et soigneusement encadrées. On dit que seuls les clubs autorisés sont sûrs, c'est pas vrai. Chez nous, on ne coupe pas l'eau, on la laisse à disposition pour pas cher. Nous veillons à ce que la salle soit spacieuse, aérée et bien éclairée, et à ce qu'il existe un *chill-out*, un endroit pour se rafraîchir. Les jeunes peuvent aller et venir librement, s'asseoir, prendre l'air. On ne s'en aperçoit pas forcément, mais l'encadrement existe, on a des infirmières sur place, on a des extincteurs. On a en permanence des gens tout prêts à intervenir en cas de besoin. Je pense qu'on va organiser des soirées plus souvent, mais je ne sais pas si c'est une bonne idée de grossir le nombre de participants, c'est moins facile d'avoir l'œil. Le climat créé par l'ecstasy nous aide bien, chacun prend soin spontanément de son voisin. »

Quadrant Park, Bootle.

156

157

Placid's colorful, rollicking manner of packing a page full of visual information finds a vivid outlet in the pages of *Maintenant*, a large-format French magazine about current affairs.

Placid is an active artist and image maker whose paintings, drawings, and comic-book art have been exhibited around France and overseas. He has also been involved with artists' self-published books and periodicals. As a graphic designer, he brings his painter-illustrator's touch to pieces like this compact-disc cover and wine-bottle label.

Mixing up display typefaces and allowing headlines to spill over onto successive text lines are characteristics of Placid's layouts for *Omnibus,* a visual-arts publication, that reflect his design approach's rambunctious spirit.

Omnibus

LA CRITIQUE

SOUS UN ANGLE GÉOMÉTRIQUE

Chaque *nouveau mensonge* de la publicité est aussi *l'aveu* de son mensonge précédent.

A ce mouvement essentiel du spectacle, qui consiste à reprendre en lui tout ce qui existait dans l'activité humaine *à l'état fluide*, pour le posséder à l'état coagulé, en tant que choses...

Guy Debord - La Société du spectacle · textes et photogrammes du film · 1973

+

« Expanded, extended » (2)
Pierre Joseph
Espace public
Rirkrit Tiravanija
LA VERSION DU RÉALISATEUR

JOURNAL D'ART - TRIMESTRIEL, NUMÉRO 24, AVRIL 1998

LA VERSION DU RÉALISATEUR

Placid has designed numerous books on non-mainstream themes for smaller, independent publishers, including these titles in a series issued by DTV/Compact Livre.

VINCENT RAVALEC

VINCENT RAVALEC CONSÉQUENCES DE LA RÉALITÉ DES MORTS

CONSÉQUENCES DE LA RÉALITÉ DES MORTS

PHOTOS CORINNE MARIAUD

DTV

Scratch

The godfather of the laser

SHE GOT OUT OF THE BLACK-AND-BLUE BARRIO AT SEVENTEEN.
CURVED LIKE AN ARC, ASS AND BREASTS PERCHED HIGH, THE POINTS ELECTRIFIED WHEN THE WEATHER GETS HUMID — OR WHEN HER MAN ENTERS HER.
BRUMM SCOOPED HER UP NEAR THE AIRPORT TERMINAL.
HE WAS PERFECT PREY FOR THE BEAST IN AMBUSH IN HER BELLY.
THE LEGACY OF THE BLACK-AND-BLUE BARRIO.

PARK THE CAR, LET GO OF THE WHEEL, UNDER THE ULTRAMODERN OFFICE, THE PYRAMIDAL BUILDING WHERE THE SOUND TRACK OF DREAMS IS RECORDED. BNU, THE DUTCH COMPACT DISC GIANT, THE GODFATHER OF THE LASER. A PYRAMID LOST IN A MAZE OF PARKING LOTS.
ELEVATOR. BACKGROUND MUSIC. THE REMIX OF THE CITY OF LIGHT, STRIDENT, METALLIC, SPITFIRE. BRUMM HUMS ALONG.
AT HIS FLOOR, THE SECRETARY SAYS :
«SHAMAN CANCELLED. THE SOUND ENGINEER'S OUT FOR BLOOD.»
BRUMM TOSSES A BLACK SPORTS JACKET ON A SWIVELING CHAIR, UNKNOTS HIS TIE, DOESN'T ANSWER. HE SITS DOWN AT HIS DESK IN HIS SLATE-COLORED-SHIRT

56

57

THIERRY MARIGNAC SCRATCH

Scratch

DTV

Bold process colors, a basic grid of quadrants, and title type that recalls a road sign give structure to Placid's catalog of the German-born, Arizona-based modern artist Rotraut's art.

© Rotraut, Phœnix, Arizona, 1996
for the works and the photographies
© Hannah Weitemeier, Berlin, 1995
for the text

The reproduced works were shown at the Stadtische Gallerie in Buttgen, Germany from October 13th until November 5th 1995

DTV
Editor Alain Levy
Graphic design Placid
Printed in France

ROTRAUT
SCULPTURES-RELIEFS

PRINCIPAL: Jean-François Porchez
FOUNDED: 1994

38 bis, avenue Augustin-Dumont
92240 Malakoff

TEL (33) 1-46.54.26.92
FAX (33) 1-46.54.26.92

Jean-François Porchez is one of France's most accomplished typographers. Born in 1964, he studied at the Atelier Nationale de Recherche Typographique and worked at Dragon Rouge, a Paris studio known for its corporate-identity and packaging schemes, before setting up his own firm. FF Angie and Apolline, Porchez's first two designs, won prizes at the Morisawa international typeface competitions; by 1994, he had created a new typeface for—and named after—*Le Monde*, France's respected national newspaper. Elegant but practical, effortlessly readable, and capable of a range of visual emotion, the Le Monde font family is the crowning achievement to date in Porchez's portfolio. In his promotional piece for this system, which resembles a newspaper, Porchez discusses the historical context and technical details that shaped this work. He brings that same meticulous, cultured understanding of the art—and science—of creating letterforms to his teaching at the École Nationale Supérieure des Arts Décoratifs and at the École de Communication Visuelle, and he writes about typography for *Étapes Graphiques*, France's leading graphic-design magazine. The young designer now distributes his work through his Porchez Typofonderie Web site (www.porcheztypo.com). His other notable typefaces include Parisine, which was developed for signage in the Paris subway, and Anisette, an all-caps face inspired by the classic works of A. M. Cassandre and other poster artists of the 1930s.

PORCHEZ TYPOFONDERIE

Among its three styles, Porchez's award-winning Angie Sans typeface proudly offers "a real italic."

Specimens *de*

CARACTÈRES

& ORNEMENTS

typographiques

Créés par Jean-François Porchez

☞ PORCHEZ *Typofonderie* distribue des
caractères de haute qualité pour typographes avertis
{demandez la liste des prix}. Elle conçoit & produit
également des caractères d'entreprise
répondant à des besoins
spécifiques.

PORCHEZ *Typofonderie*

www.porcheztypo.com *{web}*
38 bis avenue Augustin-Dumont
92240 Malakoff, France
33 {0}146 542 692 *{téléphone & fax}*
jfporchez@hol.fr *{E-mail}*

1998

The design of a pamphlet
promoting several of Porchez's
typefaces echoes the
combination of classical
discipline and contemporary
ease that is a hallmark of
this typographer's art.

A promotional piece for Porchez's Le Monde typeface series takes the form of a newspaper not unlike the one for which it was created and after which it was named. In this informative publication, with contributions from type experts around the world, Porchez offers explanatory sketches with detailed examples of the thinking and aesthetic concerns that shaped this comprehensive font family. Of special interest is his comparison of Le Monde to familiar Times Roman.

Porchez's all-caps Anisette typeface was inspired by the classic works of A. M. Cassandre and other renowned artists of the 1930s—the golden age of the poster.

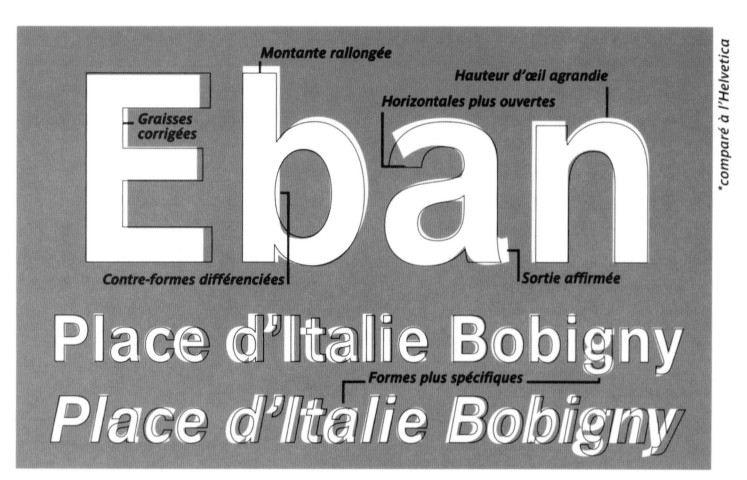

Le Parisine* *par* Jean-François Porchez

The young typographer's Parisine was developed for use in signage for the Paris subway.

A friendly, poetic roundness and interesting ligatures characterize Porchez's Apolline typeface, advertised here on a postcard.

This postcard, like a birth
announcement, informs
customers of "the birth of our
son," Porchez Typofonderie's
new Mathis typeface.

The light-gray, underlying grid that appears on Porchez Typofonderie's stationery recalls both page-layout organizing schemes and the wooden trays in which typesetters stored metal type bits during the letterpress era.

PRINCIPAL: Fabrice Praeger
FOUNDED: 1991
NUMBER OF EMPLOYEES: 1

54 bis, rue de l'Ermitage
75020 Paris
TEL (33) 1-40.33.17.00
FAX (33) 1-40.33.17.00

The young designer Fabrice Praeger emphasizes that his artistic influences do not come from the latest news, and that he does not watch television, go to the movies, or read. That may be hard to believe, but upon close inspection, speaking eloquently for itself, Praeger's work really does show that its sources lie less in current trends and more in his careful consideration of the ideas he is communicating and in a love of saying more with less—graphic elements, tools, and high-tech gadgetry, that is. After earning his philosophy diploma, Praeger studied the plastic arts; then he studied at and interned under the auspices of France's renowned École Nationale Supérieure de Création Industrielle. In 1992–1993, he worked with Les Graphistes Associés, then with the designer Gérard Paris-Clavel. Praeger's designs often use a limited palette, simple line drawings, or visual/verbal puns to powerful effect, as in his T-shirts for the Pompidou Center that employ its Jean Widmer-designed logo. "I like to spend 70 percent of my time looking for a good concept, something pertinent that will give [a project] form with the greatest economy of means," Praeger says. That his clients have included everyone from Nutella and Sony Music to big sports events and Amnesty International is a testament to the strength of his thoughtful, unaffected designs.

FABRICE PRAEGER

Praeger is especially fond of this design, with its double visual pun employing a red heart. It was reproduced in a poster for the town of Fontenay-sous-Bois and in an edition of postcards for the town of Échirolles' graphic design festival.
ART DIRECTOR/CREATIVE DIRECTOR/
DESIGNER: Fabrice Praeger

The ribbon that slips through the precisely die-cut tags in Praeger's promotional gift-wrap for *Télérama* visually completes the publication's familiar logo, with its little vertical yellow stripe to the left of the upper-case *T*. Holding down the ribbon on each package is a sticker with a smiling cartoon face, one of the symbols with which the magazine rates TV shows.
ART DIRECTOR/CREATIVE DIRECTOR/ DESIGNER: Fabrice Praeger

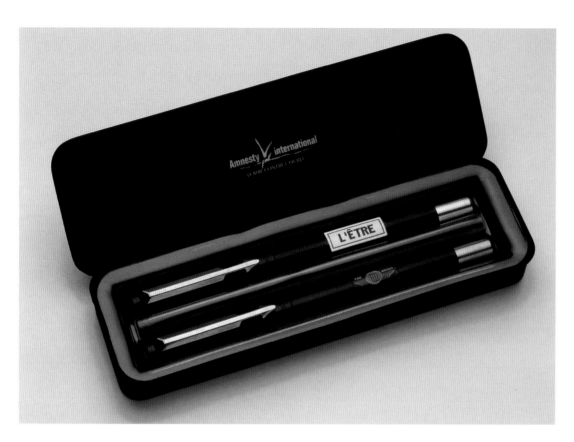

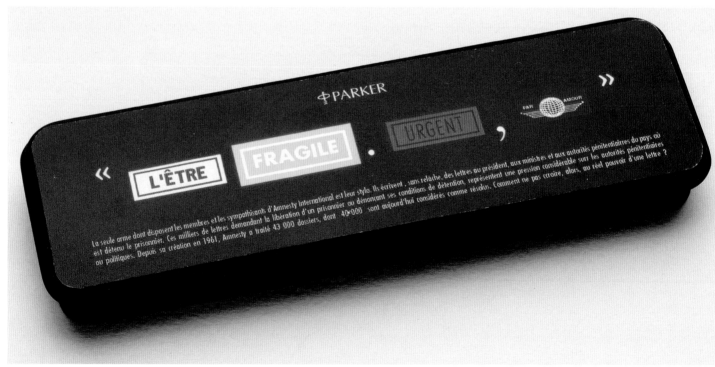

For Amnesty International in conjunction with Parker Pens, Praeger created a pen emblazoned with the words *torture* and *writing* to encourage the public to write to political leaders to show their support for human rights. As pens are removed from the display rack, the slogan "Saw through the cellblock bars with pens" becomes visible. Praeger also designed a case for a set of original labels that use verbal puns to call attention to the human condition. For example, instead of *lettre* (letter), one sticker says *l'être* (being, as in human being). On another, *par avion* (by air mail) is replaced by *par amour* (by love). Use of the stickers transforms a plain sheet of paper or a card into a statement at once philosophical, poetic, and political.

ART DIRECTOR/CREATIVE DIRECTOR/ DESIGNER: Fabrice Praeger

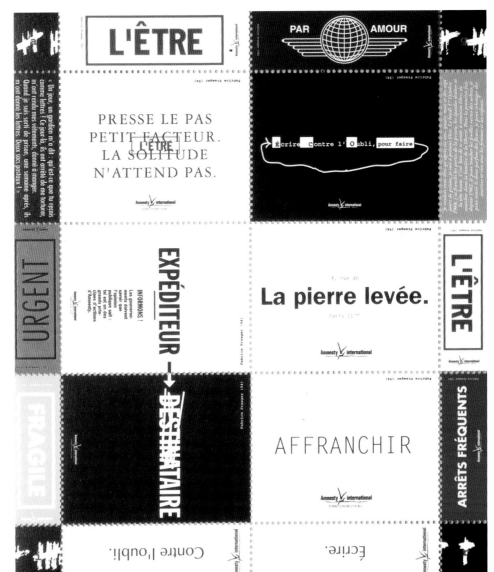

For the Pompidou Center in Paris, Praeger created a series of T-shirts, some of which feature visual puns employing its Jean Widmer-designed logo. The blocks of color in one of the designs refer to the building's famous exposed mechanical systems; its water pipes are painted green, its electrical conduits are yellow, its air ducts are blue, and its elevators and escalators are marked in red.

ART DIRECTOR/CREATIVE DIRECTOR/
DESIGNER: Fabrice Praeger

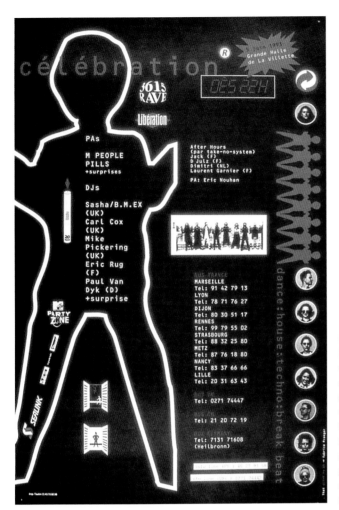

For a big rave dance event in Paris, sponsored by the national newspaper *Libération* on the occasion of its twentieth anniversary, Praeger created all the promotional graphics, including a flyer in the form of a strip of paper dolls, a poster, admission tickets, and little give-away cards.

ART DIRECTOR/CREATIVE DIRECTOR/ DESIGNER: Fabrice Praeger

PRINCIPAL: Michel Quarez

15, rue A. Poullain
93200 St. Denis, France
TEL (33) 1-48.27.55.20

Born in Damascus, Syria, Michel Quarez has worked for the most part independently, and always on his own artistic terms, since he graduated from the École Nationale Supérieure des Arts Décoratifs. In the early 1960s, he worked in the Warsaw atelier of the legendary designer-teacher Henryk Tomaszewski, where he was exposed to the spare, powerful composition and symbolism of modern Polish poster art. He has served as an art director at an advertising agency in Paris and was a cartoonist in New York. Now one of the recognized deans of French graphic design, Quarez's career marked a major milestone when he was awarded the National Grand Prize for Graphic Art in 1992. He continues to create memorable works, especially the brightly colored posters for which he is best-known, featuring a style of brushy minimalism that one critic has described as a reflection of the way Quarez "looks at the world with tenderness and irony." Composed of just a few bold, colorful brushstrokes, the characters that pop up in Quarez's posters for sports events, concerts or the theater can seem at once gently innocent and deeply serious. Such works are sometimes called *affiches d'auteur* (author's posters), accentuating the strong, singular vision that informs their creation.

MICHEL QUAREZ

Instead of using ordinary offset printing, Quarez prefers to silkscreen his posters for the punchier, more saturated color that the process affords. In this poster for the flower market in the town of Gennevilliers, the designer digitizes one of his paintings on a grand scale, and the multi-hued bouquet contrasts dramatically with the black figure.

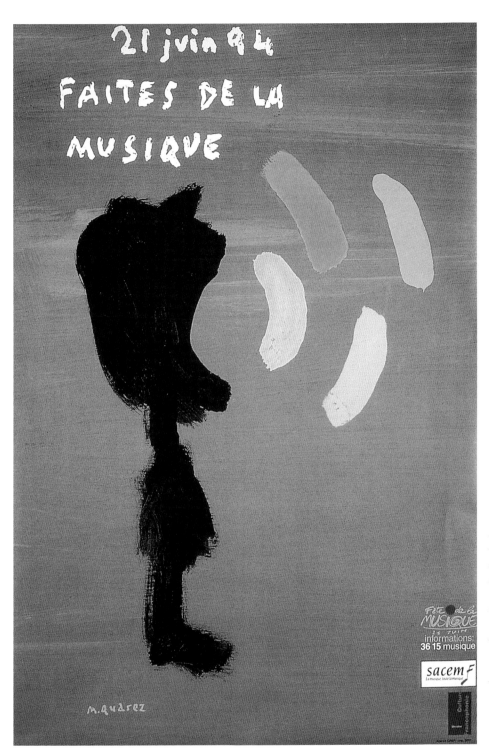

Clever puns, both visual and verbal, drive this otherwise simple image poster for a summertime music festival. Bars of color emerge from the singing figure's mouth where musical notes might usually appear in a cartoon cliché. In the slogan, *Faites de la musique* (Make music!), the word *faites* (make) is pronounced like the word *fête* (festival) in the event's name, Fête de la Musique (Music Festival)

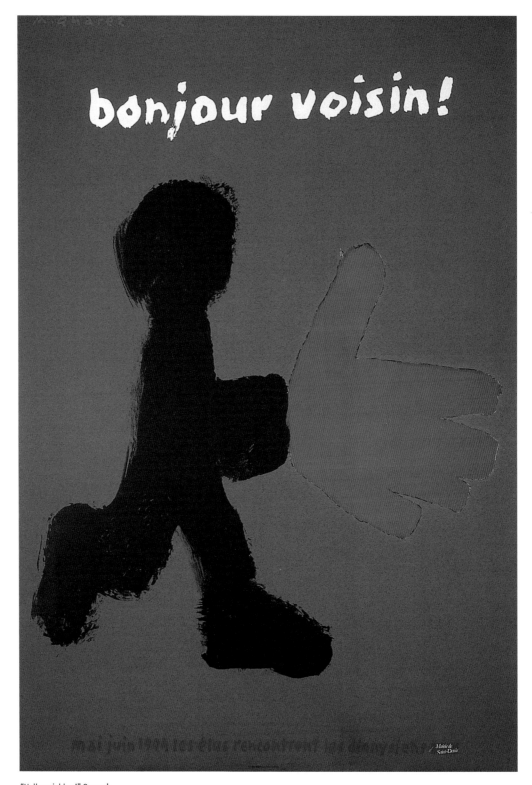

"Hello neighbor!" Quarez's figure calls out in this poster announcing a day in the suburban Paris town of St. Denis, where he lives and works, when local elected officials go out to meet their constituents.

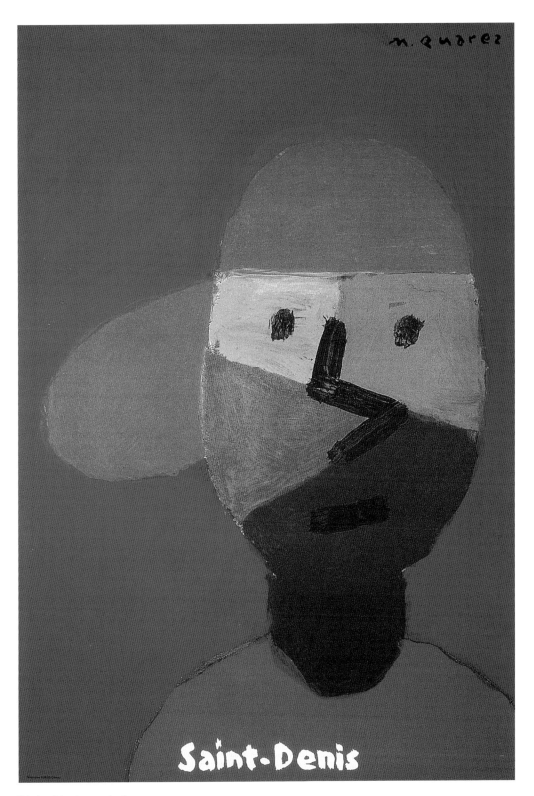

This cheerful poster promotes the
town of St. Denis, a suburb of
Paris on the southwestern edge of
the French capital.

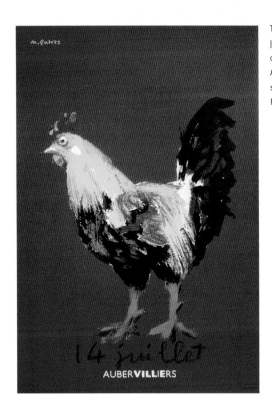

This poster for the annual July 14 celebration tells citizens of and visitors to the town of Aubervilliers that they have something to crow about on France's national holiday.

In this beautifully minimalist poster, Quarez pulls off a subtle visual pun, in which the red, missing, third vertical band of the French flag must be discerned in the luscious color field that surrounds the blue and white stripes.

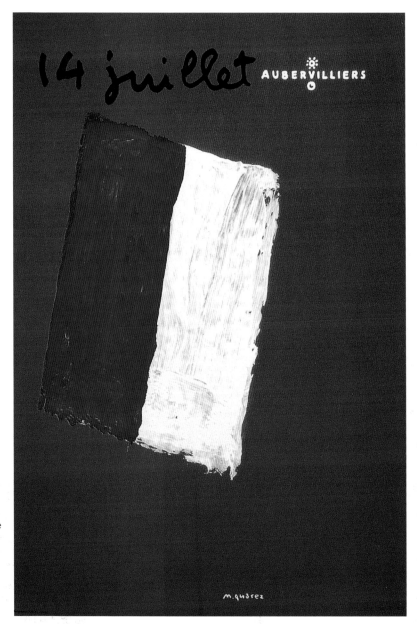

This poster plays off the familiar, often-intimidating salutation of French policemen who demand "Your papers!" (identification cards); by law, French citizens must always carry their government-issued, national I.D. cards. This poster promotes the effort, backed by some politicians, to grant legal-resident status to certain undocumented aliens in France.

Costumed figures dance together in this poster advertising a ball to mark the thirtieth anniversary of the Théâtre de la Commune.

PRINCIPALS: Philippe
Ghielmetti, Serge Bilous
FOUNDED: 1988

4, passage d'Enfer,
3ème Étage
75014 Paris
TEL (33) 1-43.21.84.01
FAX (33) 1-43.27.90.83

Philippe Ghielmetti is the prime mover behind Sketch, a small studio whose work is marked by simple, bold ideas, and whose promotional materials and communications sparkle with a bright sense of humor. As a teenager, Ghielmetti fell in love with comic-book art, which in France is appreciated with fine-art respect and is published in handsome, hardbound albums. Later, he became interested in graphic design and worked as a book designer. In the early 1980s, Ghielmetti did a stint at Tibor Kalman's M & Co. studio in New York before returning to Paris, where he established Sketch in 1988. The firm's work for publishing companies, in the area of exhibition design, and for media giants like Canal+, the French TV channel and movie-production company, is informed by Ghielmetti and partner Serge Bilous' wide-ranging interests in comics, jazz, photography, and the power of the Apple Macintosh computer. "Our work principle consists of rapidly finding ideas," Ghielmetti says. "Our credo is: 'The answer lies in the question.'" Recognizing the directness—and, frequently, the provocative edge—of many a Sketch design, he adds: "Often it's the simple concepts that mislead and amuse the public the most."

SKETCH

These covers of crime/mystery novels exude a captivatingly dark, moody, haunting ambiance. Ghielmetti produced them completely photographically without the use of the computer.
ART DIRECTOR/CREATIVE DIRECTOR:
Philippe Ghielmetti

A random pattern of graceful letters within repeated words, highlighted in primary colors, gives a percolating rhythm to a cover of a book focusing on the work of the 1930s French poster artist Francis Bernard. An accompanying invitation card for a related event is based on one of the master designer's poster motifs.

ART DIRECTOR/CREATIVE DIRECTOR:
Philippe Ghielmetti

Superimposed patterns and images, infusions of bright color, and page-wide lines of big, justified display type are the simple, powerful elements of these art-book covers.

ART DIRECTOR/CREATIVE DIRECTOR:
Philippe Ghielmetti

lettrisme

la ville
cyberne
tique de
nicolas
schoffer

Ghielmetti uses the classic, potent palette of black, white, and red for *Le Poulpe* (The Octopus), Éditions Baleine's catalog of its popular crime novels, which is printed in the form of a newspaper tabloid. This is because, the designer explains, a fictional character known as Le Poulpe "starts each of his dark adventures by reading something in the paper."

ART DIRECTOR/CREATIVE DIRECTOR:
Philippe Ghielmetti

NOËL SIMSOLO COULEUR SANG

INSTANTANES DE POLAR
BALEINE

For the covers of a series of crime novels published by Éditions Baleine, Philippe Ghielmetti used eye-popping colors and iconic photo images. He refers to these designs as homemade to distinguish them from computer-generated artwork.

ART DIRECTOR/CREATIVE DIRECTOR: Philippe Ghielmetti

GUILLAUME NICLOUX ZOOCITY

INSTANTANES DE POLAR
BALEINE

PRINCIPALS: François
Mutterer, Brigitte Leroy
FOUNDED: 1991
NUMBER OF EMPLOYEES: 3

1 bis, cité Griset
75011 Paris
TEL (33) 1-49.23.81.10
FAX (33) 1-49.23.81.17

A strong sense of structure, a dramatic touch in the handling of two-dimensional space, and a certain kind of classicism that exudes order, even in the most random-looking design, typifies the work of Studio François Mutterer et Associés. Founders François Mutterer and Brigitte Leroy both have abiding interests and considerable backgrounds in architecture, interior design, and urbanism. Mutterer brings experience in film-making, architecture, typography, and drawing/authoring a comic-book album (a highly evolved, respected art form in France) to his work. Trained in interior design, Leroy has also specialized in geography and urbanism, taught design, and worked in various studios or agencies. Leroy was the art director of the influential magazine *Architecture d'Aujourd'hui* from 1982 until 1991; Mutterer shared that responsibility with her until the two designers established their current studio. Among other work, the firm is known for its imaginative book design, installation design for museums (with related, coordinated information, and publishing systems) and outdoor graphics. Studio members include Georges Brehier, Édith Destrez, and Charly Leclercq; on its projects, the team often collaborates with outside experts, from architects and engineers to lighting designers and cartographers.

STUDIO FRANÇOIS MUTTERER
ET ASSOCIES

Studio François Mutterer et Associés created this poster and installation design for an exhibition on the theme of the dehumanizing effects of prejudice that was presented at the Grande Arche in la Défense, the center of futuristic buildings in western Paris.

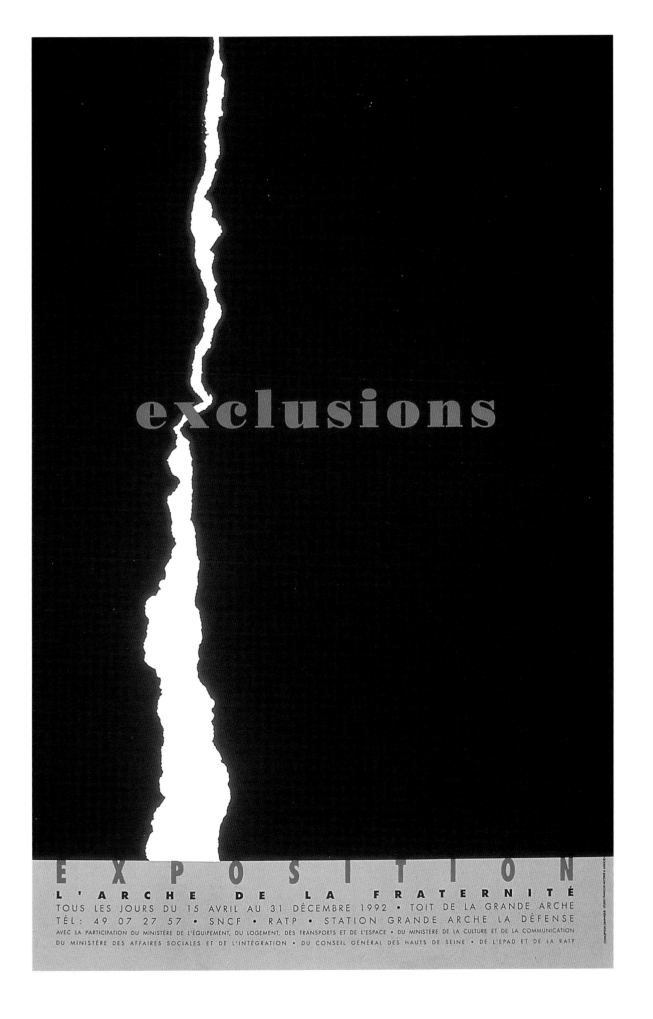

Épinay-sur-Seine

LES MURS ONT DES OREILLES

Le 4 Décembre
Marionnettes
Paroles en voyage
Théâtre du Chemin creux
Maison d'Orgemont
20 h 30

Le 11 Décembre
Conteurs
Jennie Ducloux
Praline Gay-Para
Jean-Louis le Craver
Bibliothèque
Mendès France
20 h 30

Le 12 Décembre
Ciné-conte
Princess Bride
film de Rob Reiner
Espace Lumière
20 h 30

EXPOSITION
Le Petit Poucet et ses frères
Du 3 Novembre au 31 Décembre
Bibliothèques d'Épinay

A dramatic sense of space and strong structure, even in the most random-looking designs, characterize these posters for events at a town cultural center, at a fashion- and textiles-museum, and at a regional theater.

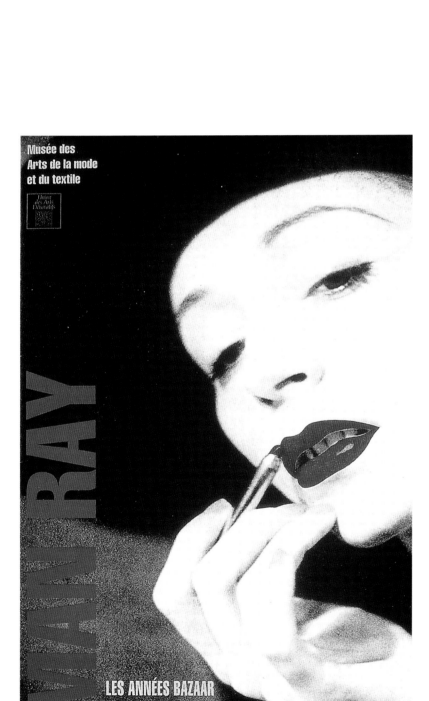

PARIS · HAUSSMANN

JEAN DES CARS & PIERRE PINON

Picard

Studio François Mutterer et Associés has designed hundreds of books, booklets, journals, newsletters, and other publications whose subjects often reflect the wide-ranging interests of Mutterer and Leroy themselves. These include many books for the Pavillon de l'Arsenal, a Paris-based institution whose collections and exhibitions focus on the architecture and urbanism of Paris.

RITES ET MYTHES

CONTEMPORAINS

SCIENCES, CRÉATEURS, CRÉATURES

ÉCOLE PRATIQUE DES HAUTES ÉTUDES, SCIENCES RELIGIEUSES
1 9 9 2

15

CONCOURS POUR LA MAISON DE LA CULTURE DU JAPON A PARIS

PRINCIPAL: Claude Benznhem,
Florence Moulin, Valérie
Ronteix, Laurence Deuley
FOUNDED: 1988

77, rue de Charonne
75011 Paris
TEL (33) 1-40.09.17.77
FAX (33) 1-40.09.16.22

Exuberant color, a painterly touch, and a sense of organization that is both clearly understandable and instantly engaging, characterize much of the Thérèse Troïka studio's work. Established in 1988, the four-person firm—including Claude Benzrihem, Florence Moulin, Valérie Ronteix, and Laurence Deuley—brings a bright palette and a sometimes playful, even festive sensibility to a wide range of graphic-design applications, from corporate-identity schemes for retailers (logos, stationery, shopping bags) to posters and publications. Much of Thérèse Troïka's work displays a seemingly instinctive understanding of design as both a tool for shaping and a visual language for describing or articulating—conceptually, functionally, aesthetically, sensuously—anything from a simple book cover to a complex museum exhibition as a navigable system of information. If Thérèse Troïka can be said to have a recognizable style, it is one in which various elements, such as display-type headlines, type treatments, passages of brushy illustration, and always-important, brilliant color perform at a consistently high, purposeful pitch. The result is designed objects, such as the studio's series of program booklets, season-schedule brochures, and posters for performances at Grenoble's Le Cargo cultural center, that are as compelling when considered individually as they are when seen and used in the larger systems of which they are a part.

THÉRÈSE TROÏKA

A hint of yellow on an all-blue ground, and an energetic mix of letterforms—some bold and sans serif; some elegant with serifs; some hand-drawn—give this cover of a brochure for a theater in the town of Gap a fetching look. Note the consistent color values here and in Thérèse Troïka's other work.

The design of a book about
historic public protests offers
vivid examples of typographic
expressionism, in which the
forms of overlapping lines of
white, dropped-out type
emulate those of marching
demonstrators winding
through the streets.

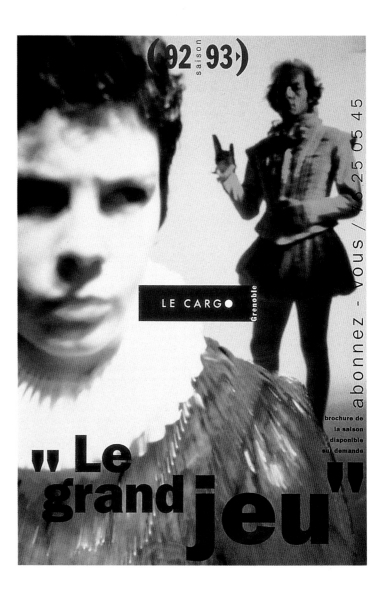

Typically bold and bright, Thérèse Troïka's program booklets, season-schedule brochures, and posters for Grenoble's Le Cargo cultural center are as compelling when considered individually as they are when viewed in the larger systems of which they are a part.

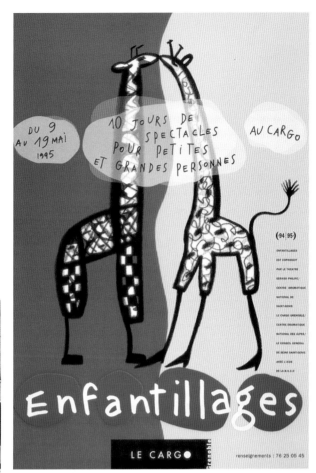

DD Color

!»#$%&'()*+,./0123456

789:;‹=›?@ABCDEF-

GHIJKLMNOPQRS-

TUVWXYZ[\]^_`abcdef

ghijklmnopqrstuvw

xyz{|}~ÄáÅàâãå-

Ç É Ñ Ö Ü -

çéèêëíìîïñóòôõöúùûü

†¢£§·¶ß®©™¨≠ÆØ∞

±≤≥¥µ∂∑∏π∫ªºΩæø¿¡

¬√ƒ≈∆«»…ÀÃÕŒœ–""''

÷◊ÿŸ/¤‹›‡·‚„‰ÂÊÁËÈÍ

ÎÏÌÓÔ Ò ÚÛÙ ı ˆ˜¯˘˙˚¸˝˛ˇ

Ensemble
préparons
Strasbourg 1998

Strasbourg
Centres Sociaux

1998 Congrès national

12, 13 et 14 juin 1998

The studio created this poster, and the logo that appears on it, for France's National Federation of Social Centers. Here, a simple combination of primary colors helps gives drama and depth to a black-and-white photo.

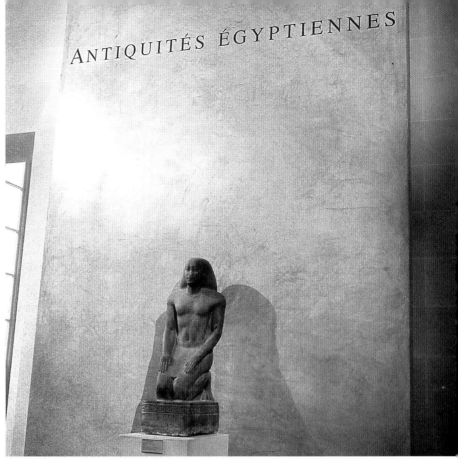

ANTIQUITÉS ÉGYPTIENNES

The studio's award-winning redesign of the installation of the Louvre's renowned collection of Egyptian antiquities showcases the sense of order and clarity that characterizes its most memorable work.

PRINCIPAL: Christophe Jacquet
FOUNDED: 1984 (began working
in computer graphics)

187, rue du Faubourg
Poissonnière
75009 Paris
TEL (33) 1-42.62.98.67
FAX (33) 1-42.52.53.49

Exploring the many facets of the meaning-conveying sign that is at the heart of postmodern semiotics is a central theme in the work of the graphic designer and visual artist known as Toffe (Christophe Jacquet). He studied at the École Nationale Supérieure des Beaux-Arts in Paris and worked in the theater as a set designer and actor. In the mid-1980s, when the Apple Macintosh computer made its debut, Toffe became the first French artist-designer to use the new equipment. He developed a visual language, even a recognizable style, that has been influenced by the computer at the same time that, with its references to food, animals and the human body, it seeks to counterbalance the culture and values that digital technology has engendered. (He has been known to computer-scan chunks of raw meat, for example, and use the resulting images in his work.) "To create is to re-appraise—or to call into question—the model and the technique," says Toffe, who feels that big advertising agencies or design studios, in placating huge corporate clients, merely perpetuate status-quo design values, restricting the artist-author's expression. Still, he created the first limited-edition, art telephone cards for France Télécom. "I have a love-hate relationship with the Mac," he admits. "It's like a troublesome love affair you can't give up."

TOFFE

Toffe's organic-confronts-techno sensibility perfectly applies to a book he designed about the work of artist Lucy Orta, who makes fantastic-futuristic garments using tents, industrial fabrics, and used clothes.

Toffe plays around with depths and layers of typographic meaning by using photographs of a conventional, plastic-letter signboard in these posters for a public-art program sponsored by one of France's regional cultural-affairs offices.

Toffe's computer-influenced
visual vocabulary is evident in
his designs of covers and actual
discs for the In Situ label,
which features recordings of
improvised, modern music.

L'Envers des Villes is a magazine in loose-leaf, portfolio format about building projects published by the Association Française d'Action Artistique, for which Toffe created these layouts.

L'ENVERS DES VILLES__

PHILIPPE BARBIER +
ERIC TORCQ

OASIS URBAINE
À BOUKHARA__

LA MÉDRESSE ISTIZA RECONVERTIE /

_____L'AFAA ET LA CAISSE
DES DÉPÔTS ET CONSIGNATIONS
SOUHAITENT CONTRIBUER PAR CE PROGRAMME
À LA CONCEPTION D'ESPACES PUBLICS
DANS LES VILLES ET LES QUARTIERS
EN AIDANT DE JEUNES PRATICIENS À EFFECTUER
DES VOYAGES D'ÉTUDE ET DE RECHERCHE À L'ÉTRANGER__
LES PROJETS DOIVENT PRENDRE EN COMPTE
LA DIMENSION HUMAINE DE L'ESPACE URBAIN
ET INTÉGRER LES PRÉOCCUPATIONS ÉCOLOGIQUES__
PLUSIEURS MISSIONS SONT ATTRIBUÉES
CHAQUE ANNÉE À DES CRÉATEURS__
CES ALLOCATIONS SONT OUVERTES
AUX MICRO-PROJETS
AUTANT QU'À DES PROBLÉMATIQUES
DE GRANDE ENVERGURE__
_____LES THÉMATIQUES RECHERCHÉES SONT
CELLES QUI APPORTENT UNE RÉPONSE INNOVANTE
À UNE QUESTION D'ACTUALITÉ
ET QUI DÉFRICHENT UN CHAMP NOUVEAU
NOTAMMENT LES ESPACES DÉLAISSÉS,
LES FRANGES, LES BANLIEUES
ET LES QUARTIERS DÉFAVORISÉS__
IL S'AGIT D'OBSERVER AUTANT L'ENVERS DES VILLES
QUE LEUR FAÇADE PRIVILÉGIÉE__
UNE ATTENTION PARTICULIÈRE EST APPORTÉE
AUX PROJETS CONCERNANT LES VILLES
QUI NE FONT PAS SYSTÉMATIQUEMENT
L'OBJET DE VOYAGES D'ÉTUDES__
LE CHOIX DE LA VILLE DOIT ÊTRE JUSTIFIÉ__

L'ENVERS DES VILLES__

This poster announces an exhibition at the Centre Culturel d'Albigeois in which thirteen artists were invited to create works on the theme of Henri de Toulouse-Lautrec.

A parade of computer-generated symbols scrolls across the cover of this folder that Toffe created for the Association Française d'Action Artistique, a government-backed foundation that promotes French art and culture overseas.

ASSOCIATION FRANÇAISE D'ACTION ARTISTIQUE
MINISTÈRE DES AFFAIRES ÉTRANGÈRES
BP 103 244 BOULEVARD SAINT GERMAIN 75327 PARIS CEDEX 07
TÉL__01 43 17 83 00 FAX__01 43 17 82 82
WEB__http://www.afaa.asso.fr
E-MAIL__infoafaa@easynet.fr

LES AIDES PERSONNALISÉES DE L'AFAA

PRINCIPALS: Charlotte Vannier, Pascal Valty
FOUNDED: 1994

8, villa du Danube
75019 Paris
TEL (33) 1-42.00.56.65
FAX (33) 1-42.00.56.66

Much of the era's best French graphic design, both in commercial applications and in the public sector—signage systems, printed matter, and logos for government agencies—is marked by a combination of stylishness and clarity, and, at the same time, to the knowing eye, by certain visible allusions to the computer techniques that have helped produce it. Into the discernible style vernacular that has emerged, designers like Charlotte Vannier and Pascal Valty inject a sense of humor and fun that often sharpens the impact of their designs and gives them a resonant and distinctive charm. They also experiment with materials and production methods, sometimes creating original, decorative promotional stamps (like postage stamps). They have also printed on industrial-purpose metal sheets and even on elegant cloth napkins (in a promotional piece for French makers of fine cutlery). Vannier and Valty have a great knack for concocting clear and clever series of the picture-symbols that have become so much a part of our international visual vocabulary. They may use them in individual or in related sets of printed pieces; they may also use them as elements of their neatly structured, easily accessed interface systems for Web sites and CD-ROMs.

CHARLOTTE VANNIER,
PASCAL VALTY
...ET TAVE MON CHIEN

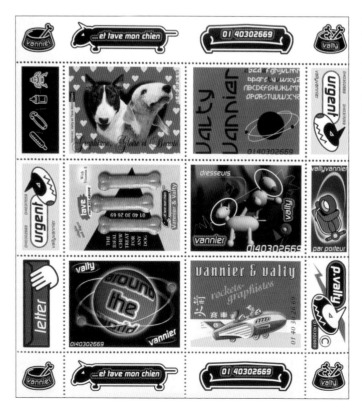

Vannier and Valty experiment with materials and production methods, sometimes creating original, decorative stamps like these to promote their studio.
CONCEPT/ART DIRECTORS: Charlotte Vannier, Pascal Valty

A clever use of picture-symbols and simple diagrammatic techniques give this birth announcement for the designers' son a futuro-techno charm. The card was printed on thick, semi-glossy cardboard and also on patterned, reflective sheet metal.

CONCEPT/ART DIRECTORS: Charlotte Vannier, Pascal Valty

A combination of contemporary
styling and elements that
evoke a sense of aviation
history—medal-like logos;
reproductions, in miniature,
of old prints—come together in
this invitation, press kit, and

Aéro-Club de France-Coupe Zénith

Concorde Aéro-Club de France-Coupe Zénith

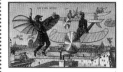

L'Agent Aviateur Aéro-Club de France-Coupe Zénith

Aéro-Club de France-Coupe Zénith

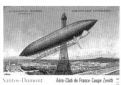

Aéro-Club de France-Coupe Zénith

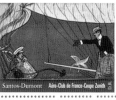

Santos-Dumont Aéro-Club de France-Coupe Zénith

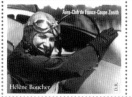

Santos-Dumont Aéro-Club de France-Coupe Zénith

ZENITH

Santos-Dumont Aéro-Club de France Coupe Zénith

Rainbow Fly Back Aéro-Club de France-Coupe Zénith

1898 é 1998

AÉRO-CLUB DE FRANCE
CENTENAIRE

Rainbow Fly Back Aéro-Club de France-Coupe Zénith

1er GRAND PRIX D'AVIATION DE L'AÉRO-CLUB DE FRANCE Circuit d'Anjou

Aéro-Club de France-Coupe Zénith

Hélène Boucher

For a CD-ROM surveying the work of the well-known modernist painter Roberto Matta, Vannier and Valty developed a series of linked screens whose layouts were inspired by the artist's fluid, spontaneous line.

CONCEPT/ART DIRECTORS: Charlotte Vannier, Pascal Valty

PUBLISHER: Music Arts and Technology Producciones Limitada

Oliver, le couteau à beurre

(10)

Après le repas, maman et Yvette ont demandé à tout le monde d'aller faire sa toilette. C'est toujours une joie de se laver surtout avec la poudre magique de Grand-mère la soupière.

Argenterie, plaisir quotidien

Pourquoi ne pas retrouver plus souvent les joies d'une belle table ?
Retrouvez chaque jour, en famille ou avec des amis, le plaisir de partager un moment privilégié autour d'une table joliment dressée, où les plats n'en seront que plus appétissants.
Une fête de chaque jour où il fait bon prendre le temps de parler, d'échanger des idées et d'apprécier les mets présentés.
Une ambiance conviviale qui donne envie de prolonger le plaisir de se retrouver.
Parce que vous hésitez encore à mettre dans le lave-vaisselle, votre argenterie, vous n'en profitez qu'en de trop rares occasions.
Mais savez-vous que le meilleur moyen d'entretenir vos couverts en argent ou en métal argenté est de les utiliser tous les jours.

(11)

This booklet for a national association of cutlery makers advises consumers that fine-metal silverware is dishwasher-safe and appropriate for everyday use.
CONCEPT/ART DIRECTOR: Charlotte Vannier

PRINCIPAL: Catherine Zask
FOUNDED: 1986

220, rue du Faubourg
Saint-Martin
75010 Paris
TEL (33) 1-44.72.92.92
FAX (33) 1-44.72.93.93

Catherine Zask's work embodies a combined sense of gracefulness, refinement, and visual poetry that is almost painterly. She has spoken of her passion for words, which she appreciates graphically, semantically, and conceptually. For this graduate of the École Supérieure d'Arts Graphiques, who won a prestigious Académie de France prize for a year of concentrated research at the Villa Medici in Rome (1993–1994), thorough analysis of the facts ("my nourishment of words") surrounding a design problem precedes her formulation of a clean, elegant, beautifully structured solution. "There is no one method, no one system, no one procedure," Zask says of her approach. "Instead, the constant is that I always have something to do with people. [Our] relationship induces the method." She prefers to work directly with decision-makers and has observed: "A good client is above all a good partner.... I don't work on projects I don't like." Independent by choice, Zask is something of a loner in her work for clients and in her own design research, in which her interest in calligraphy has evolved into a focus on letterforms. She is primarily concerned with graphic elements as signs (in the postmodernist, meaning-conveying sense) and in presenting information with extreme legibility and clarity. She has taught visual communication and has created identity schemes for universities, museums, and numerous cultural organizations, government agencies, and corporations.

CATHERINE ZASK

Black-and-white photographs, run large, counterbalance neatly laid-out text blocks in Zask's design of *En direct*, a journal published by the University of Franche-Comté.

ART DIRECTOR/CREATIVE DIRECTOR/
DESIGNER: Catherine Zask

EN DIRECT

L'IMAGERIE À L'UNIVERSITÉ

Le chercheur produit des images pour s'exprimer, faire connaître ses avancées, ses résultats, que cela soit dans le cadre de l'enseignement, de colloques, de revues scientifiques, des médias en général, ou même de la constitution de dossiers de demande d'habilitation, de financement...

L'image facilite la communication, l'accélère. Ne dit-on pas qu'une image remplace mille mots ?

Le langage de l'image est universel (il dépasse celui des langues) à la fois entre les hommes, entre l'homme et la machine et même entre les machines.

L'imagerie est un terme générique qui regroupe toutes les disciplines ou techniques ayant pour base ou pour résultat l'image. Ses champs d'application n'ont pas de limite. L'imagerie représente ainsi un sujet de choix pour prôner la pluridisciplinarité et pour réunir, dans un langage commun de communication, les spécialistes les plus divers.

C'est à cette idée que répond l'exposition "Imagerie à l'Université" proposée par Michelle Bride, directrice du Centre de Microscopie électronique de l'Université de Franche-Comté, et qui, au-delà de la présentation des méthodes et des procédés de l'image, toutes disciplines confondues, réunit les cinq universités partenaires du réseau transfrontalier : les universités de Neuchâtel, Fribourg, Lausanne, Bourgogne et Franche-Comté.

L'exposition, conçue sous une forme iti-nérante, sera d'abord présentée à Besançon, salle Proudhon, les 19 et 20 septembre. Elle s'installera ensuite à l'Université de Lausanne à partir du 22 septembre, à l'occasion du colloque transfrontalier "Communication et circulation des informations, des idées et des personnes". Elle restera à Lausanne jusqu'à la fin octobre d'où elle pourra partir à Neuchâtel, Genève, Fribourg puis Dijon, pour terminer son périple en Franche-Comté.

SEPTEMBRE 94

79

Some of Zask's most emblematic work, distinguished by its refinement, gracefulness, and legibility, can be found in her many projects for France's Société Civile des Auteurs Multimedia, an organization of multimedia authors. For this group, she has produced stationery, CD packages, invitations to events that fold out into bold posters, and event-announcement cards.

ART DIRECTOR/CREATIVE DIRECTOR/ DESIGNER: Catherine Zask

*IL N'EST PAS ACCEPTABLE QUE LA TÉLÉVISION ESSAIE D'ENTRAÎNER LE PUBLIC PAR UNE LOGIQUE INDE... -ON TRAVAUX PARIS N'A QU... CONSTRUCTION DE SUPERMARCHES ?

ALAIN TOURAINE, SOCIOLOGUE

Les mardis de la Scam*

vidéo-CD
vidéo de création
images de synthèse

Scam

Fascinated by letterforms as signs, Catherine Zask has developed her own type treatments that abstract the strokes of familiar characters within geometric grids, creating energetic, seemingly random patterns.

ART DIRECTOR/CREATIVE DIRECTOR/ DESIGNER: Catherine Zask

A gentle, random pattern of vertical hairlines and perfectly harmonized colors give refined, contemporary style to stationery and booklets for the Collège International de Philosophie in Paris, which is located, appropriately, on the rue Descartes.

ART DIRECTOR/CREATIVE DIRECTOR/ DESIGNER: Catherine Zask

For the Centre de Linguistique Appliquée, a language school within the University of Franche-Comté near the French-Swiss border, Zask created a visual identity scheme in which little geometric forms that resemble multi-colored ribbons animate each design.

ART DIRECTOR/CREATIVE DIRECTOR/ DESIGNER: Catherine Zask

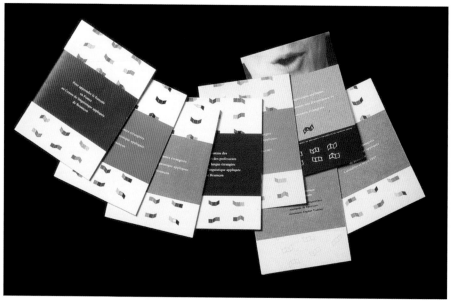

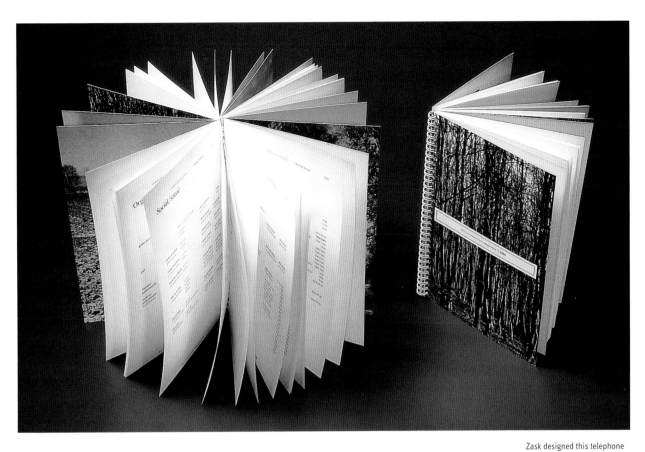

Zask designed this telephone directory for the city hall of the town of Tremblay-en-France.
ART DIRECTOR/CREATIVE DIRECTOR/ DESIGNER: Catherine Zask

The abstract, rectangular logo that Zask designed for the Musée d'Épinal, seen here in visual-identity materials for the museum, appears to evoke a window or a frame.
ART DIRECTOR/CREATIVE DIRECTOR/ DESIGNER: Catherine Zask

About the Author

EDWARD M. GOMEZ's background is in philosophy and design; he is a former cultural correspondent for *TIME* in New York, Paris, and Tokyo, and senior editor of *Metropolitan Home*. A contributing editor of *Art & Antiques* magazine, Gomez has also written on art and design for the *New York Times*, *Metropolis*, *ARTnews*, the *Japan Times*, *Condé Nast Traveler*, *Eye*, and *Raw Vision*. He is one of the contributing authors of *Le dictionnaire de la civilisation japonaise* (Hazan Éditions).

Gomez, who studied at Duke University, Oxford University, and Pratt Institute, is a visiting professor of design history and aesthetics at Pratt Institute in New York. He has won Fulbright and Asian Cultural Council fellowships to Japan for his work on the history of Japanese modern art, and Switzerland's Pro Helvetia award for his writing on the outsider artist Adolf Wölfli. Gomez has lived and worked in England, France, Italy, Jamaica, and Japan, and is now based in New York.